BOUTIQUE
BABY PHOTOGRAPHY

THE DIGITAL PHOTOGRAPHER'S GUIDE TO SUCCESS IN MATERNITY AND BABY PORTRAITURE

MIMIKA COONEY

AMHERST MEDIA, INC. ■ BUFFALO, NY

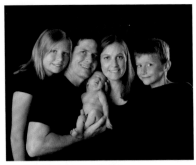
My family in June 2010.

DEDICATION

A humongous thank you to my supportive husband and loving children. You complete me and make my life full of love and happiness. Thank you so much for allowing me to be me. Thank you to my family for your love and encouragement over the years, and for believing that I can accomplish anything I put my mind to. I thank the Lord for His good grace and His guiding hand for allowing me this life. I'm so grateful.

Published by:
Amherst Media, Inc.
P.O. Box 586
Buffalo, N.Y. 14226
Fax: 716-874-4508
www.AmherstMedia.com

Publisher: Craig Alesse
Senior Editor/Production Manager: Michelle Perkins
Assistant Editor: Barbara A. Lynch-Johnt
Editorial Assistance from: Carey A. Miller, Sally Jarzab, John S. Loder
Business Manager: Adam Richards
Marketing, Sales, and Promotion Manager: Kate Neaverth
Warehouse and Fulfillment Manager: Roger Singo

ISBN-13: 978-1-60895-259-5
Library of Congress Control Number: 2011924265
Printed in The United States of America.
10 9 8 7 6 5 4 3 2 1

Check out Amherst Media's blogs at: http://portrait-photographer.blogspot.com/
http://weddingphotographer-amherstmedia.blogspot.com/

TABLE OF CONTENTS

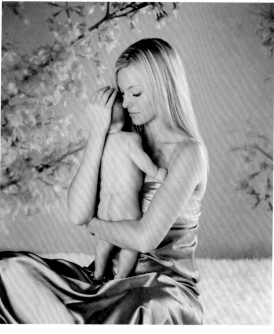

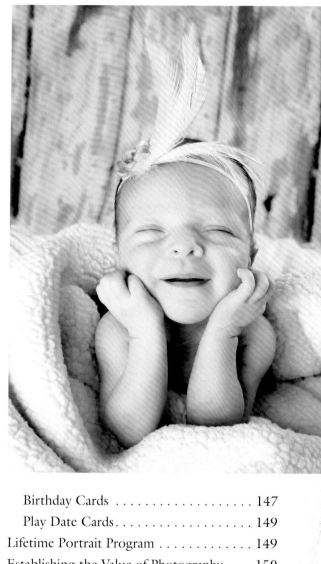

ACKNOWLEDGEMENTS

None of us can claim credit for what we know; we learn from every person who crosses our path. Each nugget I've unearthed has been a building block in my knowledge bank and I thank everyone who has shared their knowledge and experience with me. A special thanks to these photography mentors, speakers, and talents for inspiring me: David P. Macdonald, David Sault, Colin Goodwell, Rob Cooke, Richard Walker, Paul Cooper, Ray Lowe, Steve Howdle, Sandy Puc', Sarah Petty, Gerry Ghionis, Bambi Cantrell, Jeff Smith, Jeff and Kathleen Hawkins, Ed Pierce, Mitche Graf, Lito Sy, Tamara Lackey, Lori Nordstrom, Ann Monteith, Dennis Orchard, Gary Fong, Jesh de Rox, Joe Buissink, Kevin Kubota, Lena Hyde, Vicky Taufer, Jed Taufer, Mary Fisk-Taylor, Shane Greene, Lois Greenfield, and Anne Geddes.

ABOUT THE AUTHOR

Mimika Cooney is an international award-winning photographer who owns a home-based maternity and baby portrait studio based in Charlotte, NC. Born in South Africa, Mimika received her photographic training in England and is an accredited licentiate by the British Institute of Professional Photographers and the Society of Wedding and Portrait Photographers.

Along with her husband, Mimika has owned four businesses in three countries—South Africa, England, and the United States. With six years experience in web-site design, public relations, and business administration in South Africa and England, Mimika studied photography part-time and now enjoys focusing her artistic talents on offering a boutique portrait service to her American clientele.

Mimika began her photography career as a wedding photographer and made the change to a primarily portrait-based business to spend more time with her family.

INTRODUCTION

Many of us fell in love with photography for the same reason: we loved seeing our vision come to life with the click of a shutter. For some of us, myself included, photography really became our passion when we had our first children. As a sentimental romantic, I felt compelled to capture and preserve every memory of my new family using my camera. Over time, my passion and love for this craft developed until I eventually decided to turn my hobby into a career.

However, the leap from hobbyist to professional is a big one. We go from taking pictures because we love it to taking pictures to pay the bills . . . and there's not much pizzazz in that. Once the honeymoon stage is over, we have to be real with ourselves and get down to making choices that will help us keep our boats afloat. We have to figure out how to *stay* self-employed. After all, who really wants to admit defeat and go back to that boring old desk job?

Unfortunately, for many photography business owners, that dreaded scenario becomes a harsh reality. Statistically, we know that roughly 50 percent of new businesses don't survive their first five years.

If we can learn something from these failed ventures, it's that all the love in the world simply won't cut it. Simultaneously designing memorable moments, capturing them in an artistic way, and keeping all the technical aspects of your craft in the back of your mind takes practice and time.

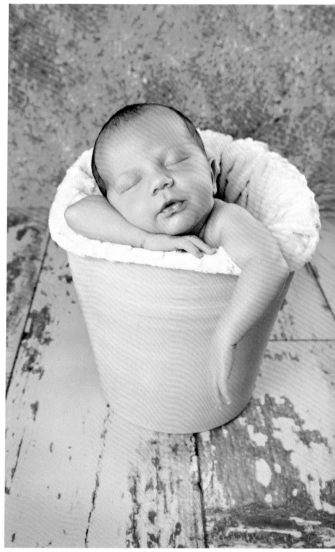

Anyone can take a picture but it takes an artist to envision and capture the perfect moment.

As the saying goes, "It takes years to become an overnight success."

First and foremost, photography is a people business; you are selling your talent, but above all

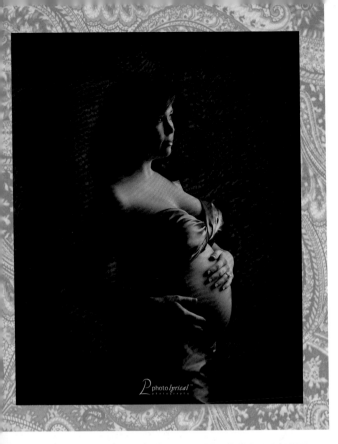

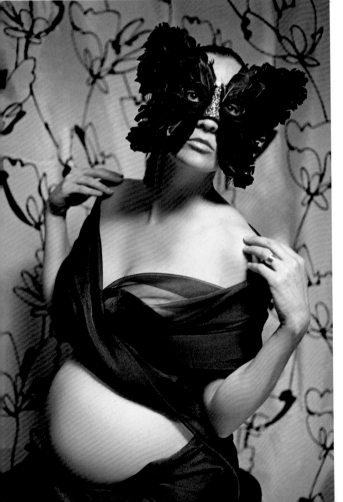

TOP—Only 50 percent of businesses survive past five years. Offering a specialized boutique approach can help your business thrive.

BOTTOM—Creating portraits with a story can contribute to your success.

you are selling your personality. If you don't already have an easy-to-like personality, you'll have to find a way to cultivate those warm, friendly aspects of your character. This is especially true for those of us who choose to work with young children and hormonal moms-to-be. In this market, you're not selling a product but an experience—and people buy from people they like.

So how does this relate to the photographer just entering the market? Well it's a good thing you're reading this book. We'll go through every aspect of building a business so that you can confidently approach the market with a plan.

Having run two of my own businesses in two countries, and having helped my husband with three of his businesses on three continents over the span of thirteen years, I've learned a great deal. My early years working in web site design, public relations, and business administration in South Africa taught me a lot about myself and my abilities. Then, building a new business in Britain forced me to learn about human psychology and to adapt to a different culture. Our third move to the United States proved to be another huge learning curve in terms of believing in myself and approaching a new cultural mind set.

What works in one country doesn't necessarily work in all—but the common thread is that every person interested in professional photography values the importance of capturing the moment. We all make purchasing decisions based on differ-

ent factors relating to our income, station, desire, wants, and beliefs, but we all agree that we'll pay for things we really want. So let's get down to baking those meat and potatoes, shall we?

What is Boutique Photography?

According to the dictionary, a boutique is "any small, exclusive business offering a customized service." As a boutique photography service, we need to aim to provide a tailored, customized, and highly personalized service to our discerning clientele. A client will pick a boutique brand over a generic one when they are motivated to find something special that no one else has, something unique that appeals to their discerning tastes, something of a higher value, and something that will appreciate in the years ahead.

Strive to provide unique products, like this collage.

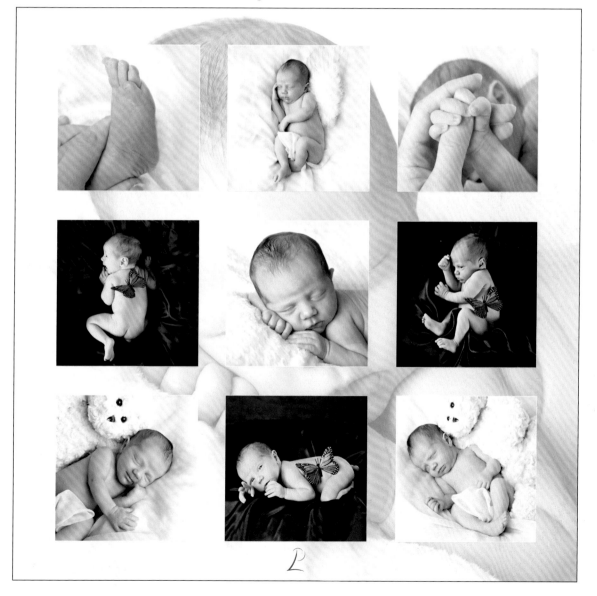

Custom photography is all about choice and experience. Contrary to what some may think, the differentiation between one boutique photographer over another usually is not about price. Therefore, who you are as a person and how your personality gels with the client are important aspects to finding the right fit. How we deliver our boutique service and how our brand is perceived greatly affect the choices a potential client will make. As a boutique brand, your style should speak for itself. Are you traditional, contemporary, or maybe photojournalistic? Your style and quality of work should be what attracts your perfect-fit client with a discerning eye for fabulous art work.

A wonderful resource called "What is Custom Photography?" is available from Marmalade Photography at their web site (www.professional childphotographer.com). It explains to potential customers what they should expect from a boutique photographer. I suggest checking it out.

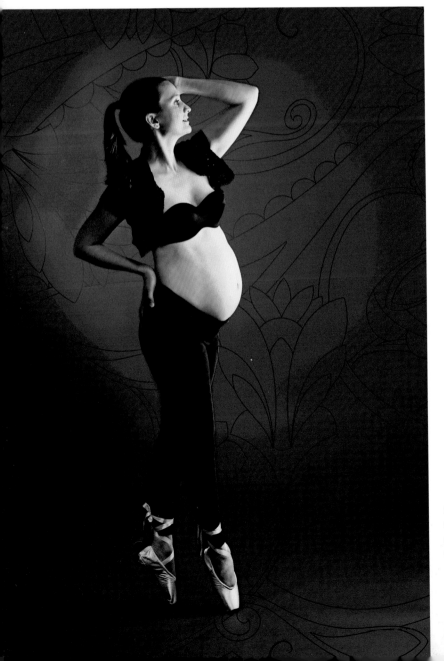

Who you are as a person and how your personality gels with the client are important aspects to finding the right fit.

1. WHAT WOMEN WANT

"They may forget what you said, but they
will never forget how you made them feel."—*Carl W. Buechner*

In a busy marketplace, we need to
offer shelter from the storm and
make a personal connection.

Some Internet sources claim we get over three-thousand mar-
keting messages thrown at us each day—and I'm sure that
number increases all the time. It has become apparent, especially
since the economy's decline in 2008, that businesses are trying

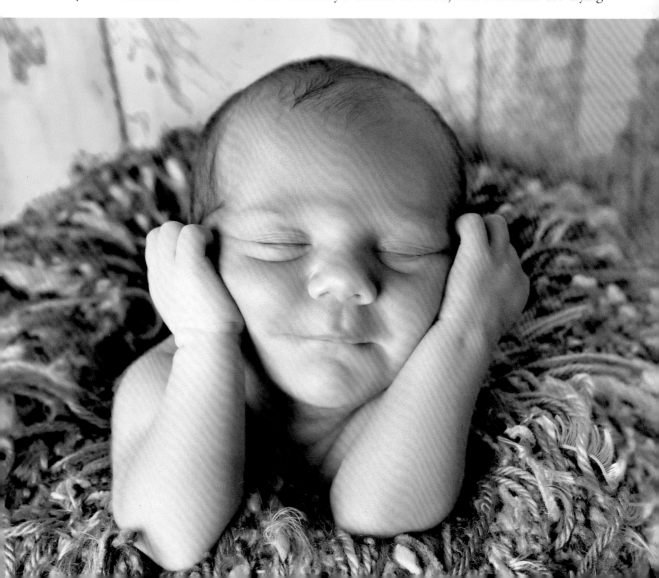

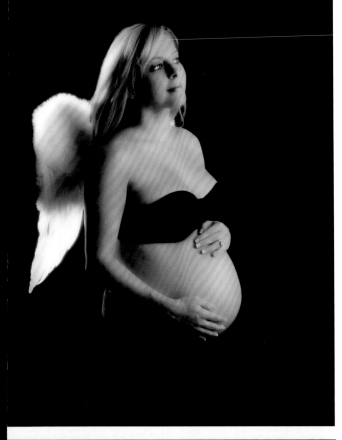

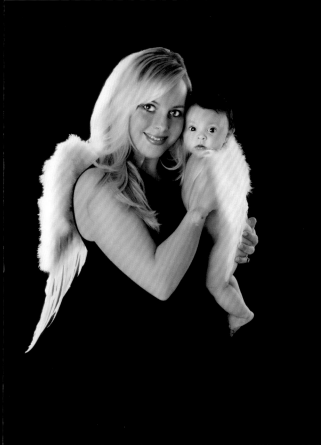

harder and harder to attract new customers and to retain any customers they can get their hands on. The gloves have come off and the competition is fiercer than it has ever been before. The speed at which industry is evolving can make your head spin. As they say, it's a dog-eat-dog world out there!

As marketers, we have roughly a gazillion possible ways to get our messages out there—cable TV, radio, Internet, blogs, podcasts, radio, Facebook, Twitter, etc. That seems like a great thing, but there's a serious downside: consumers are now flooded with such a barrage of information that they've become immune to what worked in the past. Our senses have shut down and we no longer respond to advertising stimuli like we used to. Gone are the days of placing a 2x4-inch advertisement in the local Yellow Pages or hanging a sign on our front door and expecting the phone to ring. The advertising landscape is like a tornado; we need to offer our customers shelter from the storm.

So how can a business break through the noise? And when we do, what do we want to say? To answer those questions, we need to determine who we want to be listening—whose attention we most want to attract. In the boutique baby photography business, that means we need to reach women.

BENEFITS, NOT FEATURES

Research and consumer reports have proven that the majority of household buying decisions (especially the big-ticket items like cars and houses) are made primarily by the lady of the house. As

you might imagine, males and females are wired differently and respond better to different marketing approaches. That means the elusive question "What do women want?" is something many businesses are trying to answer.

As it turns out, when it comes to purchasing, the primary difference between men and women is that men focus on the *features* while women focus on the *benefits*. Men look at the price tag and assess whether the purchase has the features to meet his demands of function ("Do we need it?"). Women look at how the product or service makes her feel ("Do they 'get' me?" or "How are they making my life easier, saving me time, and providing me with something I will love long after the price has been forgotten?").

RIGHT—The elusive question "What do women want?" is one that many businesses are trying to answer.

BELOW—Artwork that speaks for itself.

When I started writing this book, I sat on my bed with my laptop balanced on my pregnant belly. During my hours of research and Internet

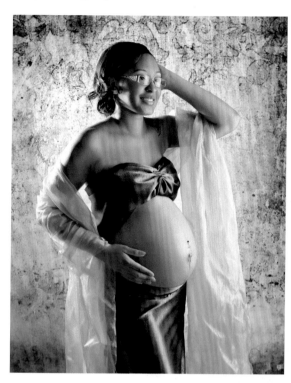

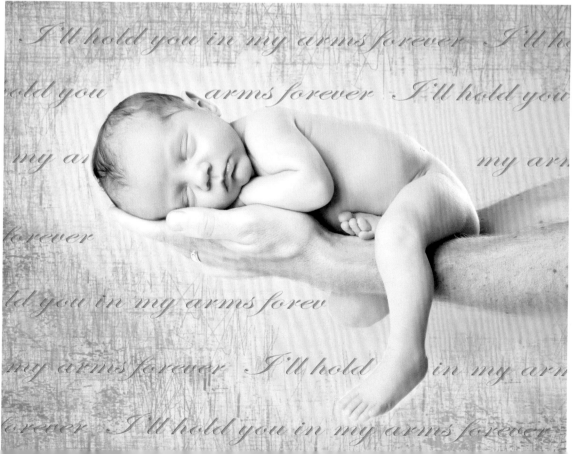

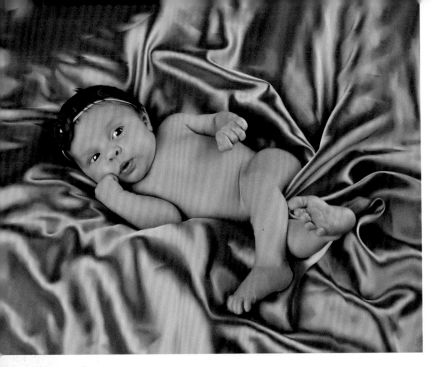

I used fabrics and props to match the gold and purple color scheme of the baby's nursery.

searches for something as simple as crib bedding, I was bombarded with such an overwhelming number of choices and marketing messages that it was hard to make heads or tails of it all. This is an experience you'll hear from a lot of moms-to-be. "The summer heat is kicking in, my feet are starting to swell and I can't stand the thought of dragging my preggy belly around the shops to find what I'm looking for. The shopping list for my baby nursery list seems overwhelming . . . crib bedding, curtains, crib styles, diaper bags, gliders, nursing accessories, safety equipment, baby clothing—the list goes on and on."

Most of us have had this experience. When we first start shopping for something, we think we know what we want. Before long, though, we're so confused by the information overload that we can't make a decision. As marketers, this should tell us that a barrage of information about print packages and pricing plans doesn't really help women choose to work with us. (And let's face it, there will always be someone cheaper than you. Creating a piranha pool of price slashing only damages the future prosperity of our businesses and will eventually result in the demise of some. Personally, this is not the kind of business landscape I wish to navigate through.)

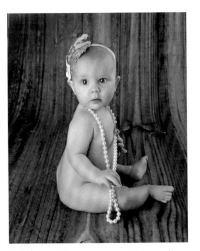

We are selling our expertise and a personal connection between ourselves and the client.

Again, rather than features, we should be thinking about communicating the benefits of booking with us. This means marketing

ourselves as a service-oriented business—it means making a personal connection.

MAKE IT PERSONAL

As photographers, the final outcome of our work is a tangible product. However, we are primarily in a service-orientated business. Beyond the final prints or albums clients will take home with them, we are selling our expertise and a personal connection between ourselves and the client.

Here's something you might hear a typical mom-to-be say: "I feel most comfortable sharing my viewpoints with a person who understands me. I want a sense of community and acceptance. Parenthood is hard work and I need all the help I can get." By providing that helping hand and a caring, guiding voice, we can help make our customers feel at peace.

Asking a prospective customer pertinent questions will help you assess their needs so you can tailor their experience for the most positive outcome. Remember: pregnant and new moms have spent a lot of time deciding on color schemes, nursery themes, textures, styles, and the benefits

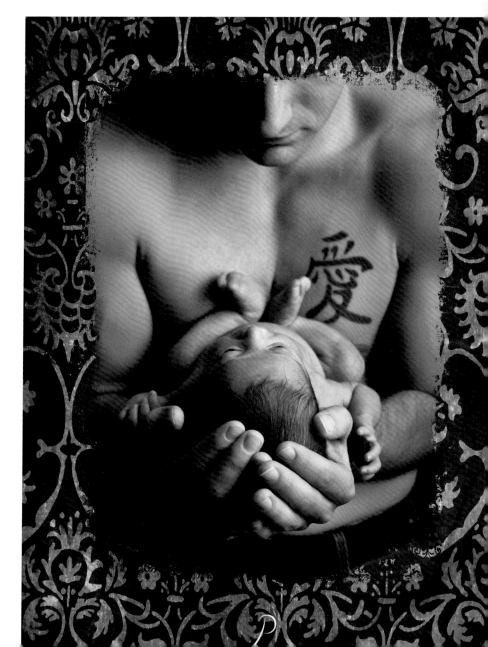

Personalize the experience and create artwork.

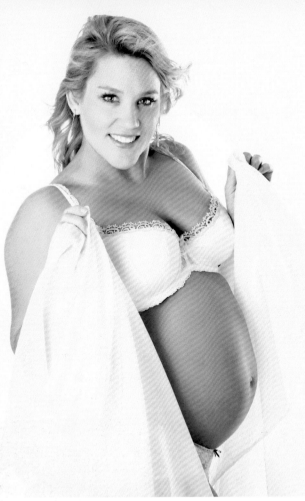

It's important to make the mom-to-be look and feel gorgeous.

of *many* purchases relating to their baby. Their professional portraits should be handled the same way—with care and understanding.

BE LIKABLE

Statistics show that consumer opinions posted online have a huge influence on the product's or business's credibility. Operations like Amazon and eBay are built around this concept. Just like Amazon shoppers, the moms in your market talk about purchases and share their experiences—both good and bad. The speed at which this exchange of opinions occurs is lighting fast. Moms get together for play dates, Tupperware parties, and girls' nights out—and they talk about *everything*. Each mom's opinion is valued.

If people like you, they will return for future purchases—and, better yet, they will refer their friends. If you offend a customer, however, you're out of the circle!

MAKE EVERYONE FEEL SPECIAL

We cannot afford to approach *any* prospect as "just another paycheck." In order to be successful, we need to understand each client's individual desires and what they're thinking. We can only hit the nail on the head if we know what direction to swing the hammer. If all you care about is the bottom line, I'm sorry to tell you: that ain't gonna cut it! Above all, remember to be nice, be helpful, and be sincere. Clients, especially women, can tell if you're being genuine.

Another way to make clients feel special is by going the extra mile at every step of the process. Ask any woman whether she likes massages, facials, manicures, and having her hair done and you'll probably get a resounding "Yes!" Why would we spend time and money on a service, like a haircut, that needs to be repeated again and again? Because the way we are treated at the salon makes us feel special! Men don't seem to understand that pretty bows, elegant tote bags, plush textures, and rave reviews from friends about a purchase make women happy. It's all in the details, boys!

We'll be returning to the idea of personalization in just about every chapter of this book. It's *that* important.

2. BUILDING YOUR BUSINESS

"It's a helluva start, being able to recognize what makes you happy."—*Lucille Ball*

I remember the very first time I experienced a darkroom. The pungent smell of the chemicals made me lightheaded. The anticipation as my photo started to appear under the red lights was so thrilling. I was giddy to see something I had envisioned and created come to life. It was immediate—I was in love. It's not as easy to pinpoint the exact moment when my hobby of photography

This little one's nursery theme was owls, so her newborn session captured this essence.

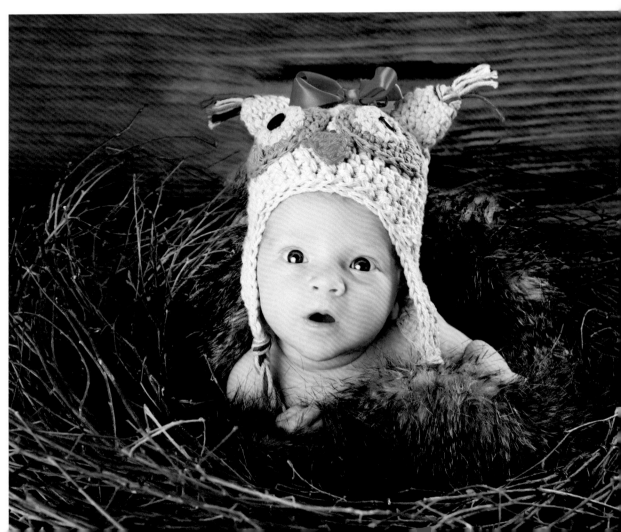

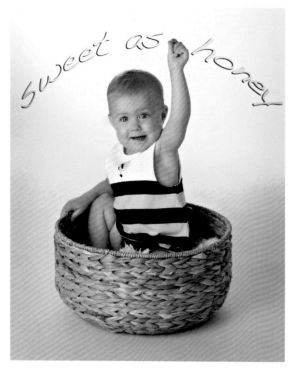

ABOVE AND FACING PAGE—Figuring out what makes you unique, what drives you, and where your talents lie will help solidify your brand

became a business; I guess it was when I started getting paid. It seemed surreal that someone was actually paying me to do what I loved. The leap from passion to profit can be a big one, though—especially if we don't have a business background or an MBA. That is why it's so important to have a plan. Let's face it, no one really *wants* to be a starving artist.

My business background isn't based in the halls of a university; it's something I learned at the school of hard knocks. I happened to grow up with a serial entrepreneur for a father, but genetic disposition isn't a requirement for business success. If you have the nose to sniff out an opportunity, the guts to give it a go, and most of all the love and passion for what you do, you're golden. Do what makes you happy!

There is no better time than the present to start a business and there are so many opportunities available if you're willing to grab them. However, before you go out and buy that fancy camera and register that domain name to set up shop, you have to have your direction established and your foundation built. Having a business plan really does help. I'm sure many of you cringe at the thought of forcing yourself to put pen to paper—you just want to take pictures! However, formulating a business plan doesn't have to be a complicated, laborious undertaking. It simply requires writing down what you're aiming for and establishing some goals to help you measure your success. As the saying goes, "If you aim for nothing, that's exactly what you'll get."

SWOT ANALYSIS

If you don't quite know where to start, you can draw out some ideas with a simple exercise. A "SWOT Analysis" is a strategic method for analyzing the strengths (S), weaknesses (W), opportunities (O), and threats (T) inherent in a project or business venture. This analysis can help you figure out your thoughts and preferences, which will go a long way toward helping you stay on track in the future.

So take out a piece of paper and an easy-flowing pen and list the following: your strengths, your weaknesses, opportunities for your business, and threats to your business. Under each category, fill in as many words as possible—anything that comes to mind. Figuring out what makes you unique, what drives you, and where your talents lie will help solidify your brand in the years to come. Armed with this kind of information you can make educated decisions about what will work best for your business—so you don't run

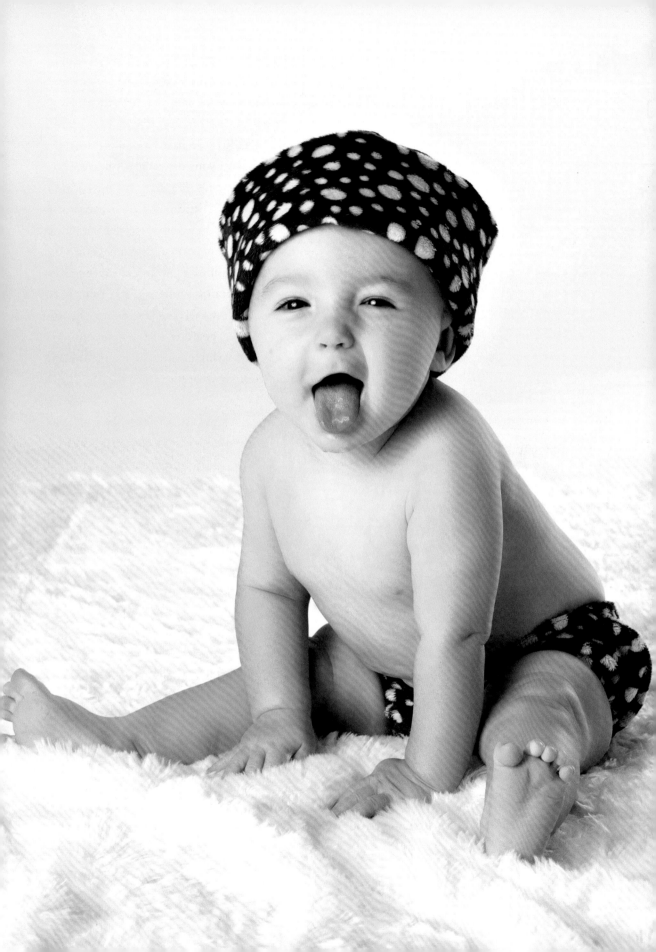

yourself ragged taking jobs just because the opportunity presents itself. Being a jack of all trades and a master of none will eventually come back to bite you on the behind! (Did I hear someone say "burnout"?)

IDENTIFY YOUR MARKET

There are three general tiers in the business landscape when it comes to affordability and motivation. It's important to decide what tier you are aiming for so you don't waste time, energy, resources, and money. Each tier has its own advantages and disadvantages, so determine what tier you will put your efforts into. Marketing to your specific target audience will greatly increase your chances of success.

The Lower Tier Client. If your goal is high volume and you want to keep yourself busy with a never-ending stream of clients, then the lower tier would probably suit you. Bear in mind that this tier is very budget-conscious; you will most likely experience "apples to apples" comparisons, since competition in this area is fierce and oversaturated. These are the type of clients who call and ask, "How much are your 8x10s?" These client don't have much (if any) brand loyalty and are easily swayed by a good deal when they hear "50 Percent Off" or "Free!" These are the clients who just want to grab a CD and run; they will also be the ones lining up at the supermarket's photo kiosk to make their own prints as cheaply as possible with no regard to how they turn out. If you start out competing in this category you will find it very hard, if not impossible, to increase your prices without losing clients.

Understandably, if you're just starting out, you probably don't have the confidence and experience to charge what you believe you are worth.

FACING PAGE—My heart has always been with babies.

As a result, you may feel you have to begin in this tier. Of course there is no harm in exploring this market to discover your "mojo." It does give you more room to make mistakes. However, be prepared to entertain the demands of this budget-conscious bunch who will try to drive you down even farther to get a good deal—they can be downright mean! They may question your abilities and complain about price. To them you will always be expensive. If you're the sensitive type, you will also need to develop a thick skin to survive the sharp claws of the competition—and hone your wits to continually come up with "special offers" to keep your deal-seeking clients coming back.

The Middle Tier Client. This level of clientele is a much more pleasant group to deal with. Most often they are your middle-class, suburban family looking for good value. They are easy to please and are enthusiastic referral-givers, telling their friends of their good find (that's you). They also love a good deal, though, so you have to show them the value in your work. They trust your judgment as an artist and look to your expertise for direction.

With this tier, you can charge more for your work, so this is a good market to get comfortable in. However, if a financial crisis hits, be prepared not to see these clients for long periods of time. Although they love what you do, when they have to reduce their family budget the first things to go will be luxuries like photography. The way to survive this is to build a large clientele pool and keep that marketing engine running. This is where you can benefit from the experience of others and buy templates and duplicate marketing strategies that

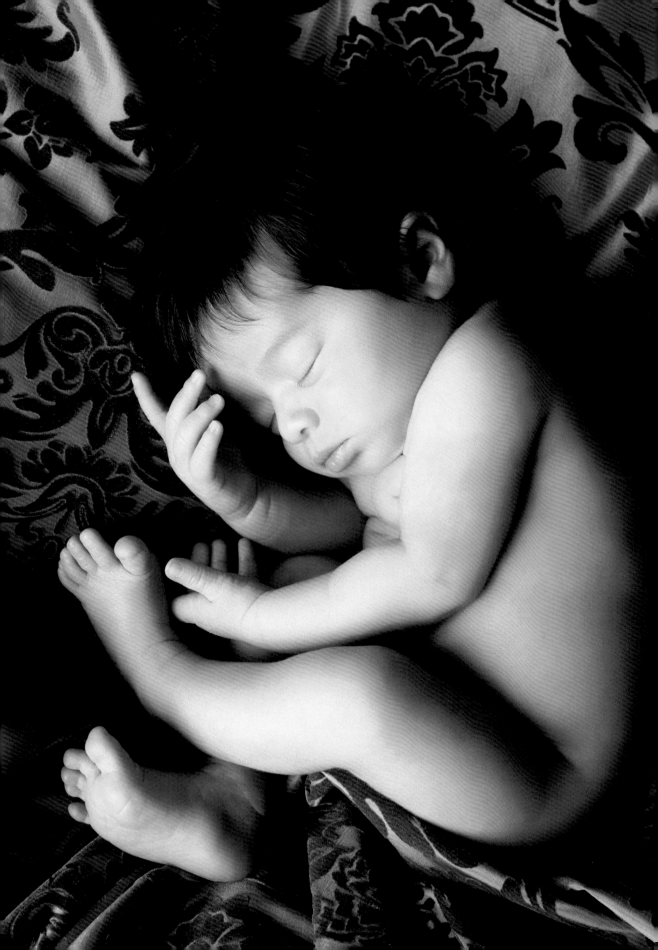

other established photographers are using. Do keep in mind that your competitors also have access to the same resources, however, so your potential client may be conflicted with the same offer from two photographers. This is where brand loyalty becomes very valuable.

The Upper Tier Client. With this client you can live the "work less, earn more" adage. Of course, there is no get-rich-quick way to building a business; it always takes blood, sweat, and tears. However, with higher paying clients you will inevitably earn more per sale since you can charge more for your work. This group gives you lots of room for creativity so you can come up with unique ideas; they tend to trust you emphatically as the professional and look to you for direction.

Brand loyalty runs deep among the upper tier clients. They are investing in the artist; they are "in love" with you and your work. These clients will seek you out for your uniqueness, your artistic vision, and your style. Often, they will even be willing to travel to you so that they can experience your "must have" brand. Delivering a quality product takes time and they are prepared to wait.

The problem? This market has a *much* smaller pool of clients and they are *much* harder to find. Quite often, they won't want to share you with others; they want to be the only one amongst their friends to have your artwork decorating their walls, so getting referrals is tricky. They also have very high expectations and expect perfection, so you cannot afford to cut corners in quality and delivery. Pretty ribbons and bows go a long way in making them happy (think Tiffany & Co. jewelry or Gucci). You are expected to deliver stellar results—high-quality products that will last and excellent customer service.

FACING PAGE—A little bit of Tiffany & Co. adds some class.

For the purposes of this book, we'll be focusing on developing a boutique brand around the middle and upper market tiers.

JUST BECAUSE YOU CAN DOESN'T MEAN YOU *SHOULD*

When we start out, most of us have little or no money to pay ourselves—let alone to pay someone else. We invest everything we earn straight back into the business to keep it afloat. However, there comes a time I like to call "the tipping point." This is when you begin to realize that you just can't fit everything into a twenty-four hour period. You're spending too much time behind the computer editing photos and not enough time bringing in the business. It feels like you're busy . . . but you can't seem to get on top of your to-do list. This is when you have to make the decision: delegate or drown!

When you force yourself to take a good look at your situation, it should be easy to identify the areas of your life where you could benefit from some help. If you break down your hourly rate, including all the tasks you squeeze in, you will realize that you're worth a pretty penny! So if you decide your rate is $100 per hour to photograph a session, why on earth would you spend five hours cleaning your house when professional cleaners would charge you $100 for all five hours? It's not rocket science—that does *not* make good business sense.

The same goes for retouching. Many photographers like to spend hours perfecting their images using every conceivable tool, template, or action they can get their hands on. That used to

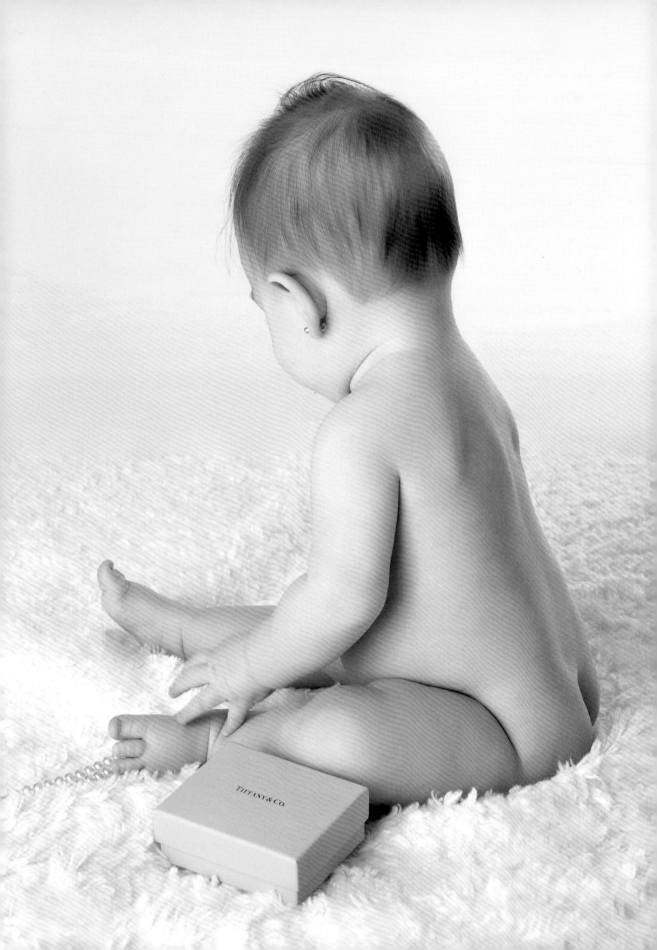

be me. However, after years of spending his evenings alone, my husband gave me an ultimatum: fix it or find something else to do. My family was the reason I became my own boss—so I could be in control of my time. However, my business was running me instead of me running my business. Something had to change. I had to buy myself time to do the things I *really* wanted to do.

After doing some research, I discovered that graduating students from the local arts college were willing to work for next to nothing—just to have the opportunity to work in a photography business. Finding such great talent was a revelation! I could pay a student *a tenth* of what I would "spend" on my own time. In fact, with the skills they had been taught, they could even show me a thing or two! I finally had my life back.

Now I'm sure many of you are thinking, "Yeah sure, that's all fine if you have the business to pay for help, but I don't have

I had to buy myself time to do the things I really wanted to do.

You should retouch for enhancement, not to fix mistakes.

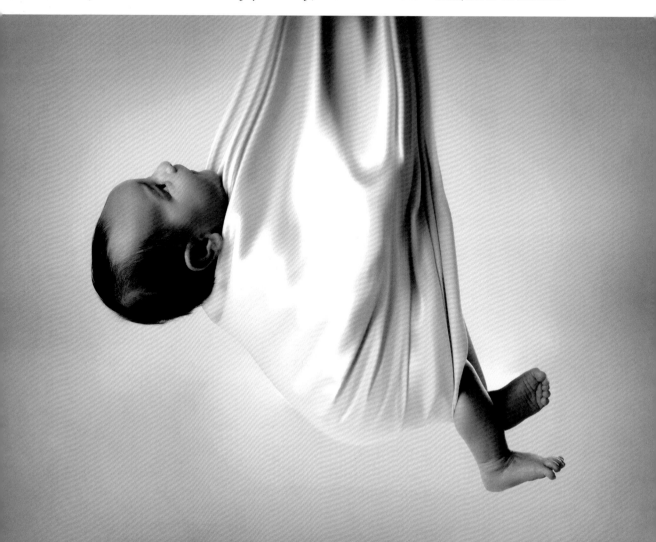

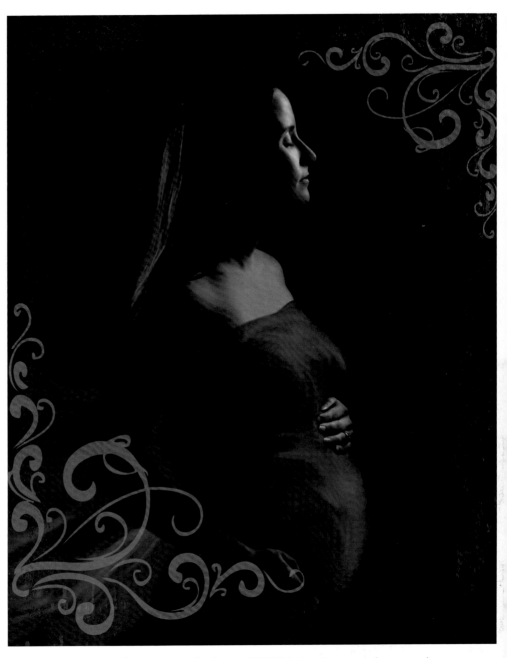

Decide how much editing an image needs and avoid getting carried away.

enough money to feed myself." This is where you have to change your mindset. You have to start charging for retouching time and build it into your cost of sales. Once you get a firm grasp on the fact that time is literally money, you will stop wasting so much of it on unnecessary tasks.

In short, just because you have the skills to do something doesn't mean doing it yourself makes financial sense. I've decided that my time is far too valuable to spend it on things I can pay someone else to do faster and cheaper. I would much rather spend

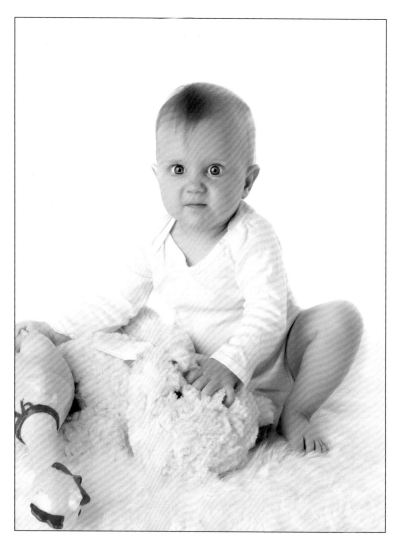

LEFT—Don't run around like a chicken with your head cut off—have a plan!

my evenings enjoying my new baby with my family than working on the computer until midnight.

GET ORGANIZED

The best way to get ahead is to have systems in place and tools that help you shorten the time it takes to finish tasks. There are many software programs available to minimize the time you spend doing repetitive tasks. For example, during my first year of shooting weddings I used to open each and every image individually in Photoshop to fine-tune the color correction and exposure (crazy, I know). Today, I use Adobe Lightroom, which helps me to apply and sync settings to a bunch of images simultaneously, thereby minimizing the time spent editing. There are other tools to get

GET IT RIGHT THE FIRST TIME

If you find yourself always having to "fix things" in Photoshop, it means you're not capturing the images right the first time. I cannot emphasize enough how important it is to get things right *in the camera*. Photoshop is there to enhance our work, not to salvage a bad job. If you find yourself in this position, you may need to spend more time perfecting your technique. We will cover this in greater detail in later chapters.

FACING PAGE—Avoid the tears and get it right in the camera.

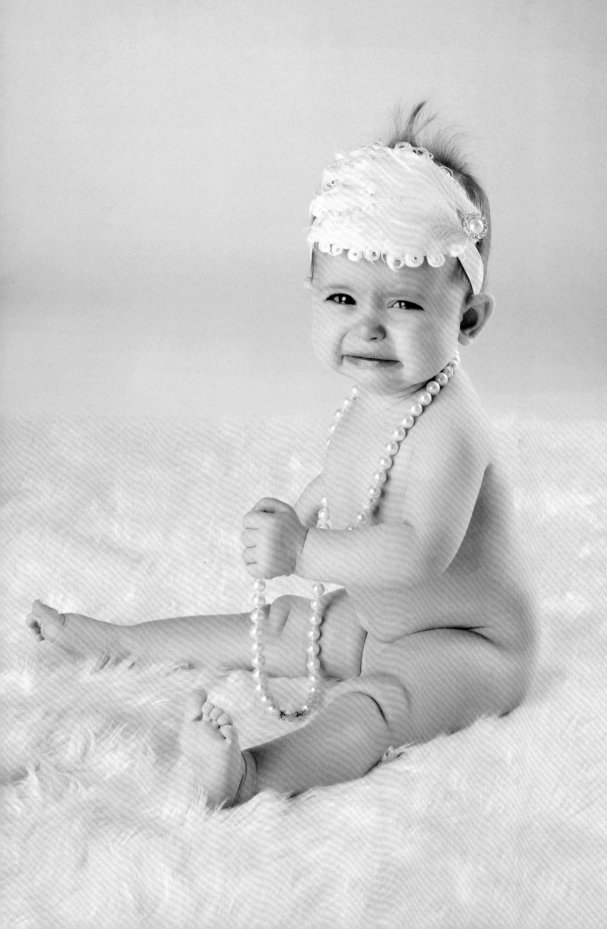

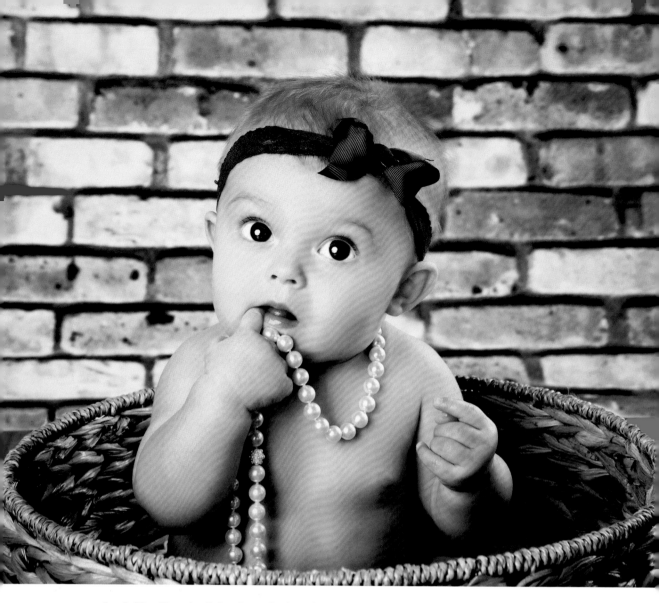

you organized, like Google Calendar, which is free and allows you to share your schedule with others so you can more easily schedule appointments. Time organization tools like BrownBookIt (www .brownbookit.com) allow customers to pick and pay for their pre-ferred appointment date online. Most of all, I recommend using a studio management program like Successware (www.successware .net) to keep you on top of your business so you can accurately determine your prices, know your numbers, set your goals, and plan your finances with the click of a button. Once you have your systems in place, you will have the peace of mind and confidence that you are actually running your business—it will no longer be running you!

Think about what equipment you really need and avoid unnecessary expenditures.

BECOME THE SPECIALIST

Being a jack-of-all-trades general practitioner just doesn't work anymore. Consumers want to know that they are investing their money with someone who knows what they are doing and who understands their needs. Painting everyone with the same broad brush will not produce the desired results; not everyone is into the same shade of green. Become the best you can be within your particular area of expertise and people will find you.

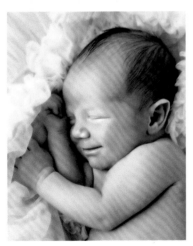

Consumer focus has come back full circle to quality and making value-driven purchasing decisions.

LIGHTS, CAMERA, ACTION!

Don't you just love it when someone says to you, "What a great picture—you must have a great camera."? It's like saying to an artist, "Nice masterpiece—you must have nice brushes." Right. It's not the camera that maketh the artist but the person behind the camera that maketh the art! Having made my peace with the clueless, I've accepted that not everyone is going to appreciate my skills.

Still, there are some choices to be made when it comes to picking the right tools and equipment. There is no right or wrong choice, however; it's a matter of preference. My advice is to always buy the best quality you can afford and the most recent models. Canon and Nikon, the two biggest players in the camera market, offer some excellent quality cameras even in their prosumer range. To effectively take control of your craft you need to use an SLR camera with interchangeable lenses. Often, it's the lens more than the camera that determines the quality of your results, so invest your money in top-quality glass.

Along with any equipment purchase, you should also find a little printed book called "the manual." If you're like me, it's a tedious task reading it—but it sure does explain things. So read it and get to know how your equipment works.

ADAPTING IN HARD TIMES

Before our economic bubble burst recently, people could often find the money to buy the things they really wanted. Subsequent to the decline, most people and businesses have felt the financial crunch. This has affected every tier of the buying market, so we've all had to learn to be more creative. Consumer focus has come back full circle to quality and making value-driven purchasing decisions.

This is similar to where the economy was thirty to fifty years ago. For example, back in the 1960s, the lady of the house invested confidently in her refrigerator because she knew that the brand was built to last for years and years. Purchasing decisions were based on quality and longevity. With the advent of cheaper manufacturing processes, the focus eventually turned to making things fast and making things cheap.

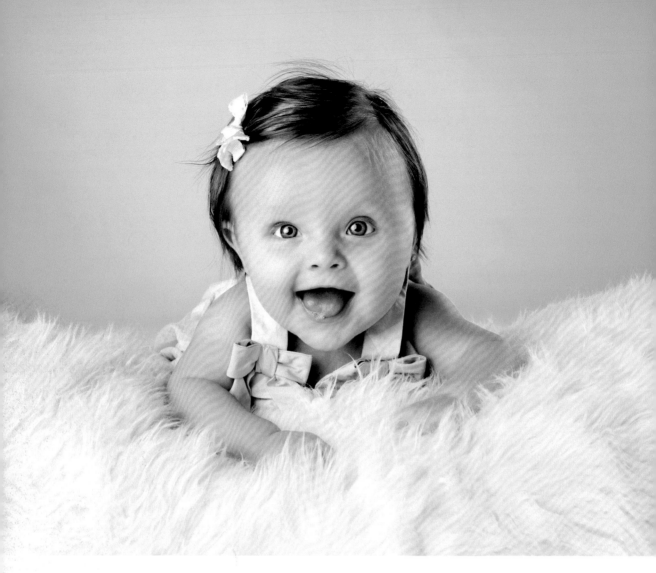

It's the same in our industry; just a few decades ago, the skills of professional photographers were revered. The general consumer wouldn't have dreamed of trying to compete with the professional whose expertise and equipment were out of their reach. Today, however, cameras have become more and more affordable. Accordingly, a major barrier to entering the field of professional photography has been lowered. Most middle-class families can afford a decent camera that produces acceptable results. This has resulted in people cutting expenses by doing children's and family portraits themselves.

For the professional photographer, this means we need to sharpen our skills, adapting to the new way of thinking and being more creative in how we attract clients.

There's a big gap in quality between a plain snapshot and a stunning portrait.

PATIENCE IS A VIRTUE

We've all heard it before, but there really is no way around this one: only time and patience will eventually get you to where you want to be. There is no easy method, template, mailing list, or other magical ingredient that will catapult your business into the stratosphere. It's a collection of many things. Think of it like building a castle; it's only accomplished by painstakingly laying down one brick at a time. Just like a fly wheel, it takes some effort and a hard push to get it moving, but once it gains momentum it turns easily. If you're in it for the long haul, you're in store for great things!

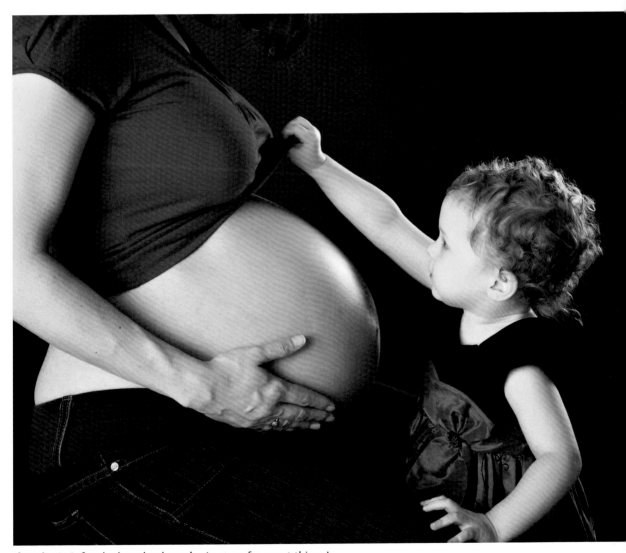

If you're in it for the long haul, you're in store for great things!

3. MARKETING 101

"Begin doing what you want to do now. We have only this moment,
sparkling like a star in our hand—and melting like a snowflake."—*Marie Beyon Ray*

When I moved to the United States from England and started my photography business for the second time, I was essentially a 50/50 wedding and portrait business. I wanted to get my name out in the local market so I started attending a networking group that met once a week to exchange business ideas and share referrals. This was my first introduction to what Americans call their "elevator pitch." This is essentially a very pared-down infomercial about who you are and what you do—all presented in

thirty seconds (roughly the time you'd have to pitch your business to a prospect you met on an elevator).

Every week we would go around the table and each person would introduce themselves in thirty seconds or less, explaining their business, product, or service. At the end of their pitch, they would highlight their "tag" line—a single sentence that would stick in your mind. I thought I was being cute when I picked "I photograph anything that blinks!" What transpired was that I

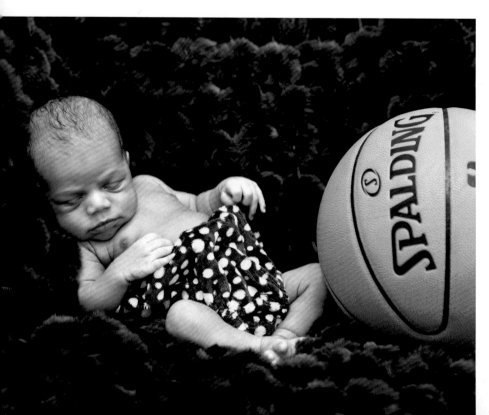

LEFT AND FACING PAGE—My true message is capturing the essence of new life.

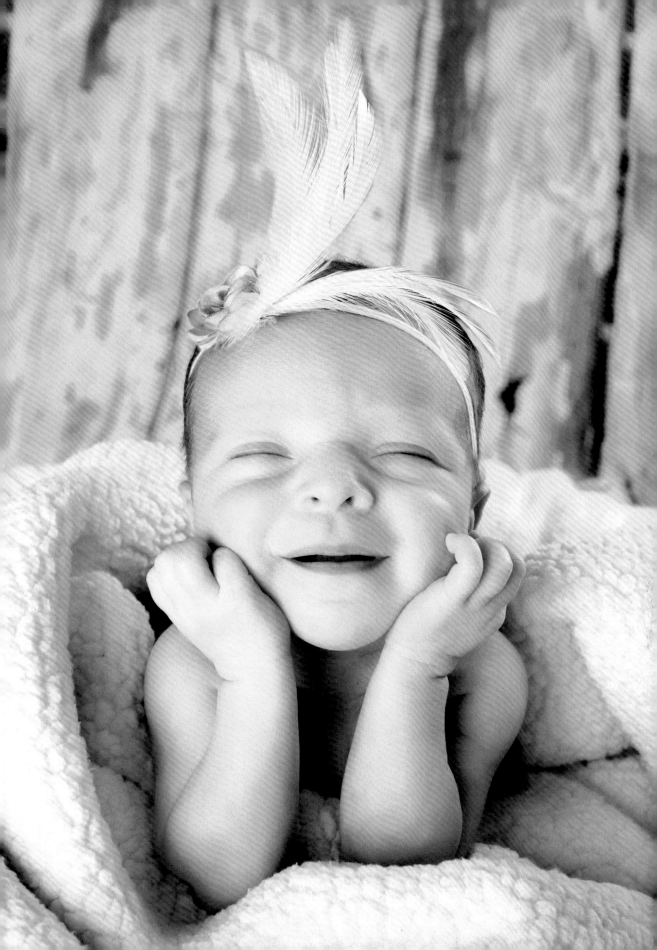

was getting inquiries about whether I could photograph business head shots, pets, cars after they had been crashed, a child's birthday party, party food, social parties, the insides of homes, etc. Yes, my phone was ringing . . . but these calls weren't taking me in the direction I really wanted to go. I had to draw a line in the sand, remove the "anything that blinks" line from my elevator pitch, and home in on my true message.

BEFORE YOU REGRET IT

When we first start out, we want to get our name out there. As a result, we develop a compulsive need to be everywhere—in every area and in every market. Realistically, of course, we cannot be all things to all people. Therefore, spending our money willy-nilly on every print ad or Internet offer will only burn a painful hole in our wallets. You know what I'm talking about. You pick up your local family magazine and see the ad for Joe Soap down the road, who just happens to be giving away a free session and free prints. You get this sinking feeling in your stomach, your heart rate increases, and you start to panic. Before you know it, you're signing up for a twelve-month advertising contract you can't afford. STOP. Take

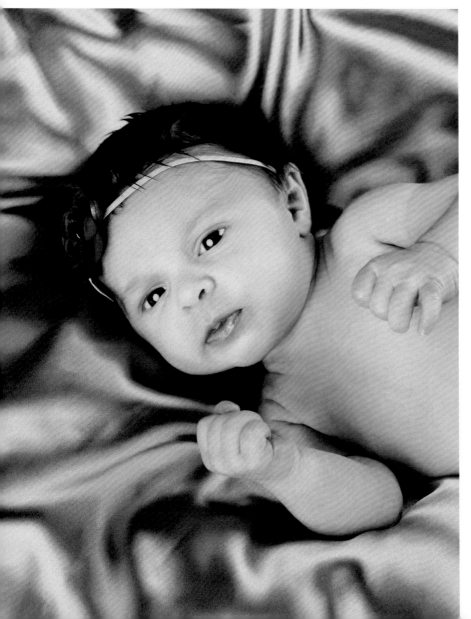

Identifying your core message will help you target your advertising more effectively.

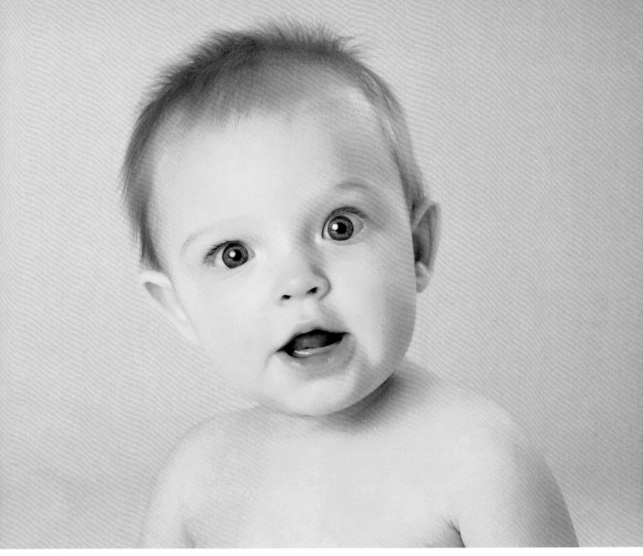

Just relax!

a breather, get a cup of tea, and chillax. Let's approach this process more logically.

BECOME YOUR OWN ADVERTISING AGENCY

Very few self-employed photographers can afford the services of a professional advertising agency to help us run our marketing campaigns. But just as a professional ad executive would do when designing a new campaign, you can build a plan that is centered on the core values of your target audience. To get started, here are some pertinent questions you need to ask yourself about your target audience:

- Where do they buy?
- What do they like?
- What is their spending power?
- What are their tastes?
- What inspires and moves them?

Once you have a blueprint sketch of who your customers are, then you can make decisions that will steer you in the right direction.

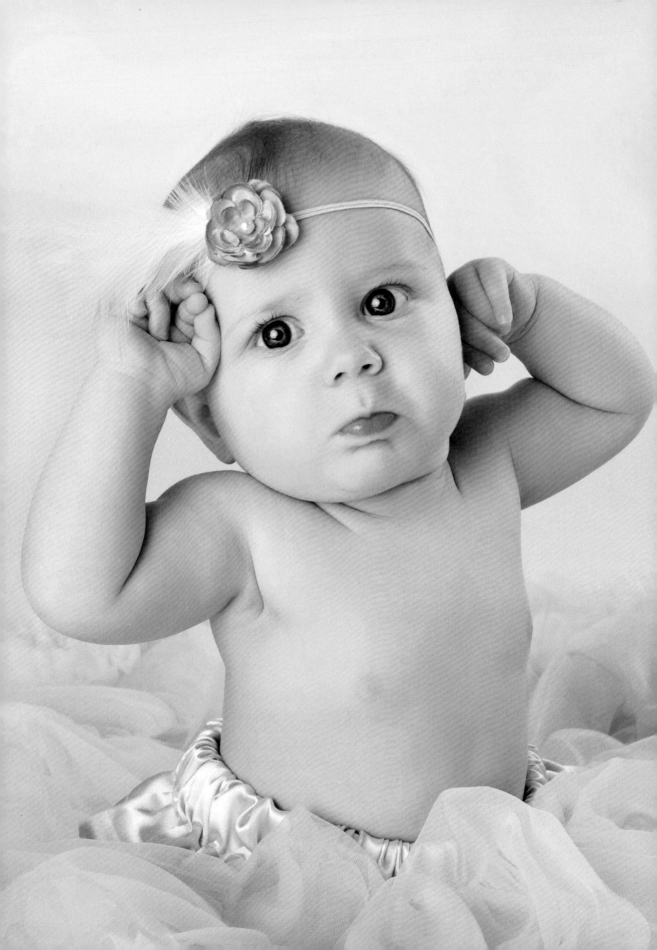

WHAT'S YOUR ONE THING?

An advertising executive would also ask you, "What is your core message?" You should be able to reply in one sentence. If you don't know what your "one thing" is, you need to take a long, hard look at yourself and read chapter 2 again. Defining your core message will give you a barometer by which to measure all opportunities—especially those that require you to spend money. This will help ensure you get a return on your investment. Given that you're reading this book, you probably want to focus on the maternity, baby, and child portrait business—so that's a good start!

SILENCE THE NOISE

Every day, thousands of marketing messages bombard us at lightning speed through television, radio, the Internet, highway billboards, magazines, e-mail messages, Facebook posts, etc. As a result of this information overload, we've developed mental filters that only allow the most finely-tuned messages to permeate our consciousness. Today, we respond only to messages that meet us where we're at and match what we're looking for at that precise moment in time. For example, when I was pregnant I seemed to see pregnant women everywhere. Similarly, it was only after a visit from my Porsche-driving brother-in-law that I noticed how many people in my neighborhood—where I've lived for three years!—drive Porsches (okay, it *was* sportscar convention week). If something is not foremost in our minds, we tune it out. This explains why so much money spent on advertising is wasted; it hasn't been spent in the right place or at the right time.

THE "KISS" APPROACH TO BRANDING

Here is somewhere you actually get to use the "Keep It Simple Stupid" axiom. When it comes to branding, you want your business to stand out in a busy marketplace. Keeping your message simple will have more of an effect than over-complicating it with words and waffle. You also need to keep your tag line, business colors, logo, wording, and photography style consistent and in line with who you are. If you keep changing your message or your logo, no one is going to recognize you. Keep it simple, stick to it, and you'll get through to your potential customers.

AN ADVERTISING EDUCATION

In advertising, the term "return on investment" (ROI) is used often. It's an important way of determining whether the money you spend is resulting in profits for your business. For photographers, it's a way of determining whether we are actually running a business or just spending money on an expensive hobby. In advertising, we also use the terms "above the line" (ATL), "below the line" (BTL), and "through the line" (TTL) to communicate how we are tailoring our advertising techniques.

ATL Advertising. ATL advertising is conducted through the mass media: television, radio, and newspaper. An ATL approach is broad and hopes to attract customers using a generic message. It's how we brand a product or service. Think of the soft drink billboard at a sporting event. It's hard to measure the success of an ATL campaign; how many people lining up at the re-

freshment stand are buying their choice of soft drink because they saw the billboard?

BTL Advertising. BTL advertising is conducted through print magazines, journals, direct mail, etc., and targeted at individuals according to their specific needs, tastes, and preferences. BTL methods can actually lead to tangible busi-

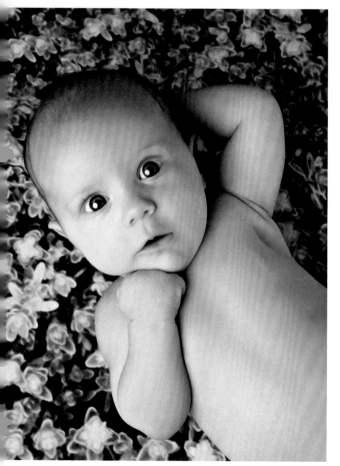

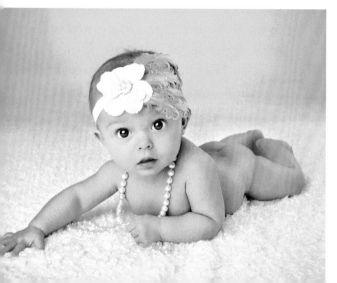

ness. We can accurately measure the success of a BTL campaign, thereby giving us insight into our return on investment (ROI). Think a of Google AdSense advertisement; you can measure how many clicks and views it got, so you know if you received business directly from it.

TTL Advertising. TTL advertising is defined as using both ATL and BTL methods, thereby going "through the line."

Shifting to an Online Approach. In the last five years, there has been a shift of focus from using traditional mediums of advertising in both ATL and BTL methods to more online methods. This is not to say that the traditional print magazine is as dead as a dodo (well, not yet anyway), but the advertising industry is quickly moving toward a paperless existence. Aside from the cost of paper and printed materials, consumers are simply not responding to traditional advertising mediums like they used to due to information overload.

In terms of a photography business, it's important to understand that there *are* ways to determine whether your efforts are providing you a good return—and to understand which ones give you the best ROI. In my opinion, as photographers we should be focusing our advertising on these areas where we can measure our results. Since our budgets are very tight, this lets us spend our money as wisely as possible.

MARKETING (PULL), NOT ADVERTISING (PUSH)

I consider advertising a one-way conversation; the company is "pushing" their message to tell

Keep it simple and create portraits with pop.

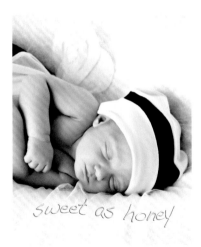

sweet as honey

Images that tell a story draw clients to your message.

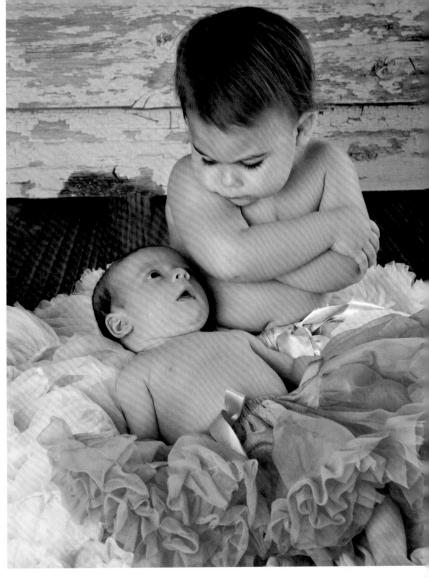

Marketing, or a pull strategy, is far more effective at creating a demand.

me what they have to offer. With marketing, we are creating more of a two-way conversation; the company is creating a "pull" for their product or service. Marketing, or a pull strategy, is far more effective at creating a demand.

Here's a good example: I love my television's digital video recorder—in fact, I refuse to watch a program live. I record it, then watch later so I don't have to sit through all the ads. By fast forwarding to the parts I choose to watch, I can fully enjoy my favorite programs. This also means I can watch two programs in the time I used to watch one. For television advertisers, this also means that they've had to get clever to get my attention. Welcome product placement. Advertisers have figured out that they can create a "pull" for their products by showing us how they work.

What this means for photographers is that we can longer expect to succeed just by "pushing" our business cards under prospects' noses. We have to create a "pull" for what we have to offer by establishing a desire for our style, a demand for our quality, and an eagerness for our way of doing business. Gone are the days of putting an ad in the Yellow Pages and waiting for your phone to ring.

THE "WIIFM?" ATTITUDE

People are inherently selfish. We are consumed by our wants, desires, thoughts, and ambitions. If your marketing message does not answer the consumer's most prevalent mental question ("What's in it for me?" or WIIFM?), it's done and dusted before it leaves the starting blocks. You have to answer why it is that *you* are the photographer for *them*. If all you're saying is, "Look at me! Look what I want to sell you!" your message will be tuned out. Worse yet, you could come across as arrogant and self-indulgent. Instead, you should be saying "I want to help you. What I have to offer is going to meet your needs."

THE THREE-MONTH SALES CYCLE

I have a love/hate relationship with the telephone. Back in the days when I was working with my husband in our Internet marketing company, I did a lot of cold calling. It meant psyching myself up to pick up the phone to introduce our services. After hearing "no" after "no" after "no," we kept ourselves from going insane with this saying: "We're one 'no' closer to a 'yes.'"

I reckon you'll hear "no" about ten times until you get that one "yes." So we developed another saying: "Fill the pipe." With every call we made, we were filling the pipe of prospects. Eventually the results would start to emerge as a trickle. After time, the trickle would become a steady flow and then a fast pour. There are some things that are beyond our control and time is definitely one of them. When you start a new promotion, though, you need to keep in mind that it will take at least three months to see results. Don't get disappointed until you do the time.

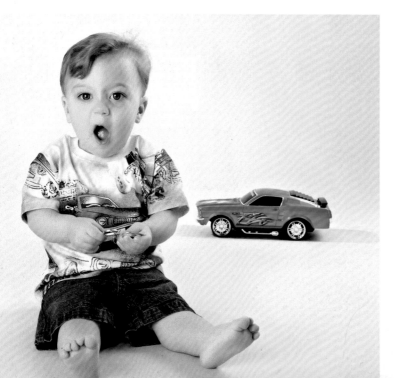

You should be telling clients, "I want to help you. What I have to offer is going to meet your needs."

4. MAXIMIZING YOUR WEB SITE

"Business has only two basic functions: marketing and innovation." —*Peter F. Drucker*

Years ago, business was conducted on Main Street, where you'd find the butcher, the baker, and the candlestick maker right next door to each other. Times have sure changed. I clearly remember the day back in 1995 I first laid eyes on the "Internet." I just knew things would never be the same. The Internet has provided a platform where information is readily at our fingertips. To

Choose images that will help you stand out in a busy marketplace.

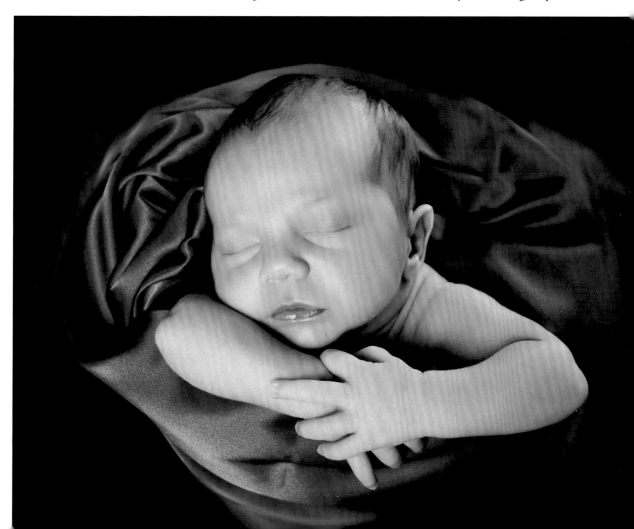

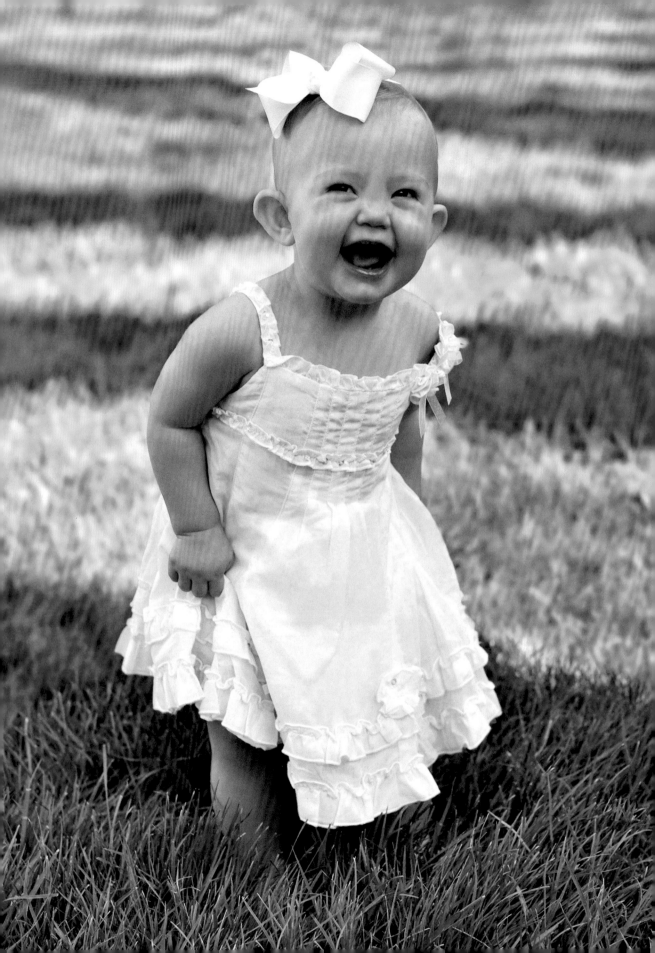

many, it feels like you're navigating the deep seas without a compass, but negotiating the digital world doesn't have to be that scary if you follow some basic guidelines for making the Internet and your web site work for you.

PARK YOUR NAME

If you've been fighting the trend to put your business online, you have to face the music. Without a web site there is no way you can compete in today's marketplace. The very first thing you need to do is get your web site up. Your web site is your online business card and resumé. It is a storefront that's open all day, every day.

There are many service providers out there that will register your domain name (your web site address), provide hosting (monthly rental space for your site), and design elements (templates or from scratch). Before you part with your cash, however, consider some of the following pointers.

WEB SITE DESIGN BASICS

A web site must have a purpose. Ask yourself what you want to achieve with your web site. Most baby photographers have an initial goal of attracting more customers. Getting visitors to your web site is important, and it is normally the measurement used to determine if a web site is successful or not. However, attracting more visitors is only part of the measure of success. Attracting *the correct visitors* from your target market is cru-

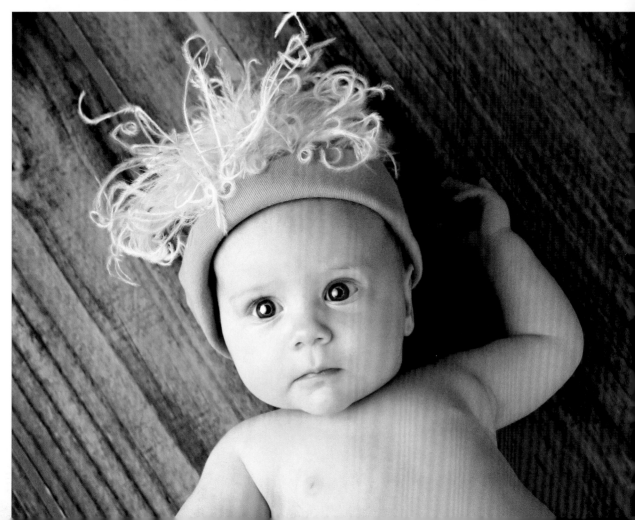

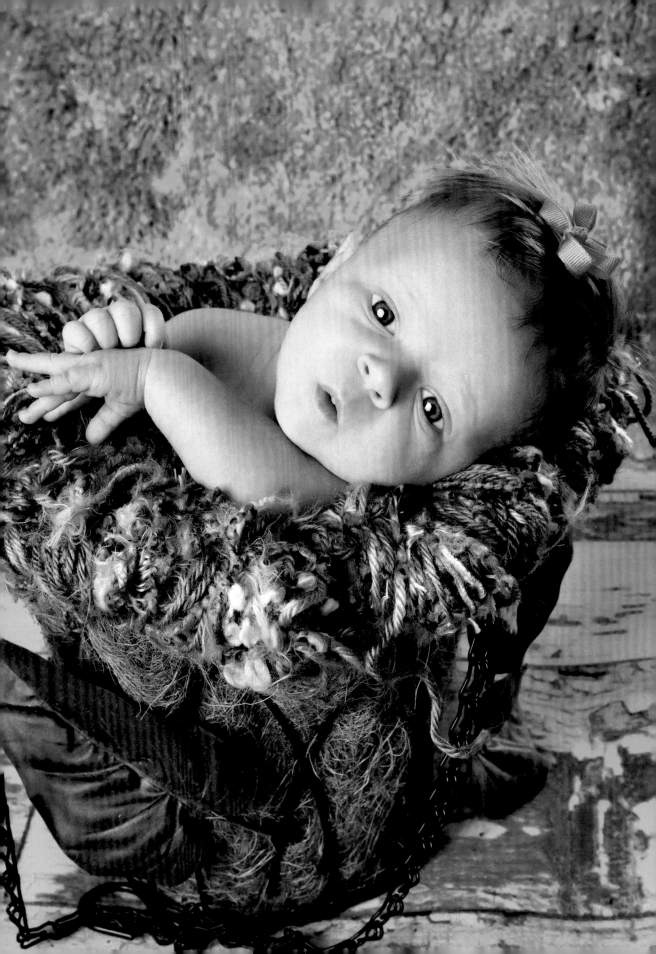

cial. Once you get them to your web site, you also need to communicate a strong message that will achieve your objectives.

Before you start figuring out how to get a web site or improve on an existing one, I suggest you take a moment to think about the following four points:

1. **Who is your target market?** As a baby photographer, your target market is mothers or mothers-to-be. Keeping this in mind will help you focus the content of your web site.

2. **What do your visitors want?** What information can you provide to answer their questions about your style, your policies, and your product offerings?

3. **What is the purpose or objective of your web site?** You may want to attract new customers, to become more connected with your customers (mediums like blogs and Facebook can also help with this), and/or keep existing clients happy.

4. **What primary message do you want to communicate?** This is important to consider. You have a lot to say, but focusing on a primary message helps you channel your message and get a better conversion rate from visitor to paying customer.

SEARCH ENGINE OPTIMIZATION (SEO)

Your web site is a great place to generate new clients, but how can you generate traffic to it? One of the primary methods is through search engine optimization (we'll look at other strategies later in this chapter).

Search engines have become the place people go to find what they're looking for. Google is the most widely used search engine, but Yahoo and Bing are also popular. Search engines aim to provide a relevant result for a user's specific keyword search. To do this, the search engines index web sites according to the information, or text, provided on their pages. On a regular basis, Google uses "spiders" to search through web sites (a process called "crawling") and catalogs a variety of information so that it can evaluate each site's usefulness. Search engine optimization (SEO) is a way for web sites to improve the results of this analysis, thereby improving the visibility of the web site in search results.

To show the search engines that your web site is both useful and relevant, you need to create a web site that the search engines can index and display when searching for your keywords. Developing clear, content-rich structure for your site will be beneficial to your visitors but it also helps the search engines—and it gives them a reason to stay longer. If you don't provide enough text, or the right text, your web site won't rank highly in users' search results, making it basically useless. Let's walk through the process.

Step 1: Select Keywords. Picking the right keywords is an important part of ensuring visitors will find your web site. Google has a free tool at www.google.com/sktool that you can use to determine the correct keywords for your site. You can be specific and narrow it down to your location (by city) to further enhance the results. Using this tool is an education. You may find for example that "child photographer Texas" gets

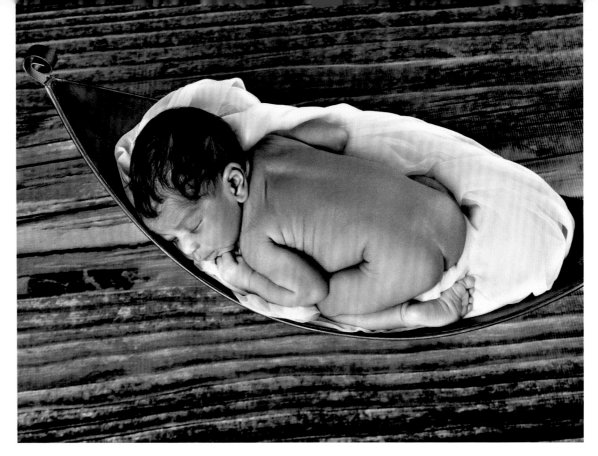

more results than "child photography Texas." However, selecting keywords that get the most results may not work in your favor; "photographer" may get 50,000 results, while "child photographer" gets 7,000—which is a lot more specific. Even better is "child photographer Austin Texas." It will provide a far more accurate and relevant result.

Google recently released "Google Instant," a search enhancement that displays results as you are typing so you get better results faster. It means that you don't have to type the entire search term before you see the results. The idea is that we read faster than we type—and with the speed at which business is moving, the faster the results are provided the better. Seeing results as we type provides instant feedback as well as offering information on what other similar keywords are used by people searching for photographers, so you can alter your keywords if necessary.

Step 2: Build Content. The services you provide can be put into words, and these words are the content that is the backbone to your web site. The popularity of blogs has significantly boosted the importance of providing relevant content. If you think you

ABOVE AND FACING PAGE— Describe your images in words for added content benefit.

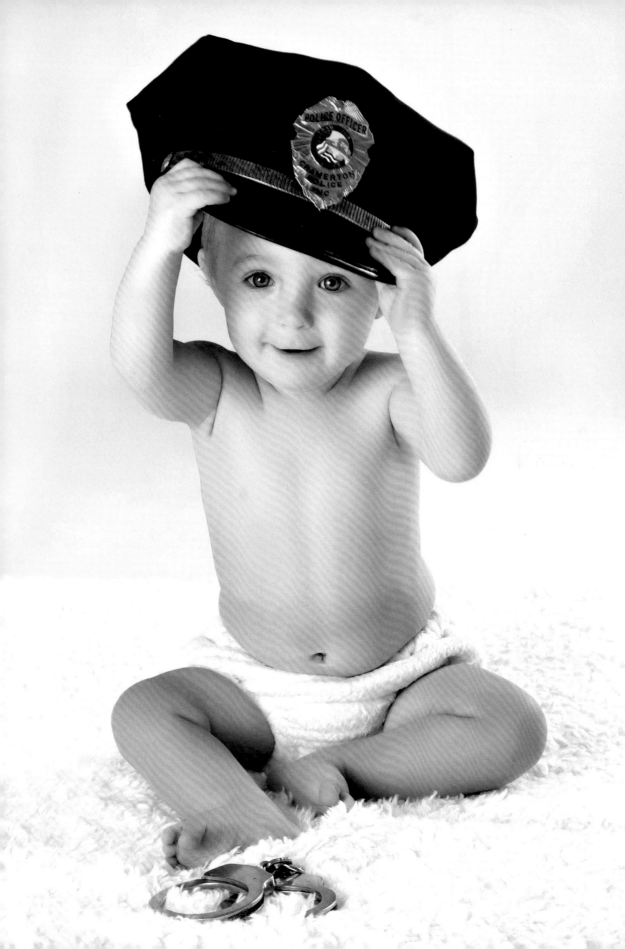

can't write, try putting into words what you say on a daily basis when you talk to potential customers about your service. This is content you can use. Keep your content fresh and regularly updated.

There are several blog platforms (Wordpress, Tumblr, Blogger, etc.) that provide templates you can customize to your needs. The beauty of operating a blog is that it is heavily content-driven and you can easily update that content on a regular basis. Some photographers have opted to merge their web site and blog with great success so they only need to keep one platform up to date. I personally like the interactivity a blog offers so visitors can post their comments. This is valuable information you can use.

Each page has to have a primary message—one clear and concise message that is backed up by your keywords. Of course we are in the image business, so our photos also tell an important story. But you can describe your photos and further expand their narrative.

A warning: Do not plagiarize! It may seem easy to copy what someone else—someone in another state or country—has on their web site, but that is a big no-no. Google will put you in the

A web site's title.

A web site's heading.

A web site's home page serves as a base for all further links.

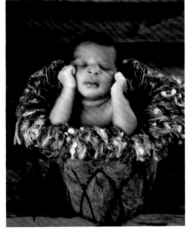

Photos tell an important story, but you can describe them to further expand their narrative.

sand box (an actual Google term) if you duplicate content from another web site. They can determine where the original content came from, so it's just not worth the risk.

Step 3: Incorporate Keywords Correctly. You need to build a page of information around your selected keywords. For example, if you have the keywords "baby photographer," you should build a page talking about you as a baby photographer.

Your keywords should appear in the page title. This is not shown on the web site itself but in the browser's title bar (above the menu buttons). For this example, your page should have the title "baby photographer." It's even more important to focus on a local area, so add the location—like "Baby Photographer Texas." The same keywords should be used as your heading; this is the text that appears within the browser window on a "tab" below the tools but above the site content.

Finally, adding keywords in the body text helps increase the relevancy. Describe what interests you and build confidence in your visitors so they know what makes you a great baby photographer. You can also use photos and slide shows to illustrate what you are talking about, but talking about yourself personally as a baby photographer helps you connect better with your visitors.

TOOLS FROM GOOGLE

Google offers numerous tools designed to help you determine the quality and performance of your web site. The PageRank tool can also be useful in determining the ranking of a site with which you might choose to do business or share reciprocal links.

Google PageRank. To find the Google ranking of a web site, download and install Google's Toolbar (www.google.com/toolbar/ff/index.html). Quit and restart your browser, then click the wrench icon at the far right side of the toolbar. The first check box you will see is for PageRank. Click the check box to activate this feature. Now, you will be able to see the rank of any page you visit on the web by clicking on (or hovering over) the icon on your toolbar.

Google Analytics. Google provides a free service for analyzing the performance of your web site. To get it, visit www.google.com/analytics. Google Analytics is a snippet of code with a unique identifier that you paste into the background of your web site. You can sign up for free and create an account where you can add many different web site addresses to track. The code is not visible to visitors, so it does not affect the way your web site looks. This service provides you with useful information about how visitors engage with your web site so that you can track

how long they spend there, the keywords they used to find the site, and where they are from. All of this information can help you make decisions about your business and how to further target your marketing efforts.

SEO DOS AND DON'TS

If you rely on search engines to bring visitors to your web site, then you have to play by their rules. The following are some things to be aware of as you make design decisions about your web site.

Black Hat Techniques. Black hat techniques are design manipulations that will result in your web site being de-listed or "blacklisted" on search engines.

Using Hidden Content/Keywords. Search engines want to rank your web site and page based on visible content. There are a number of techniques that have been employed in the past to create hidden keywords on a page. Google has modified their algorithm to detect this hidden content, which can now result in a penalty.

Cloaking. Cloaking is used to show the search engine spiders a different page than humans visiting the site would actually read. Providing a good experience for human visitors is the whole point of SEO, so this is to be avoided.

Connecting to Link Farms. A key factor in determining the placement of a web page within Google's search engine results are links back to your site from other relevant web sites. Link farms, however, often offer reciprocal link ex-

FACING PAGE—Describe what interests you and build confidence in your visitors so they know what makes you a great baby photographer.

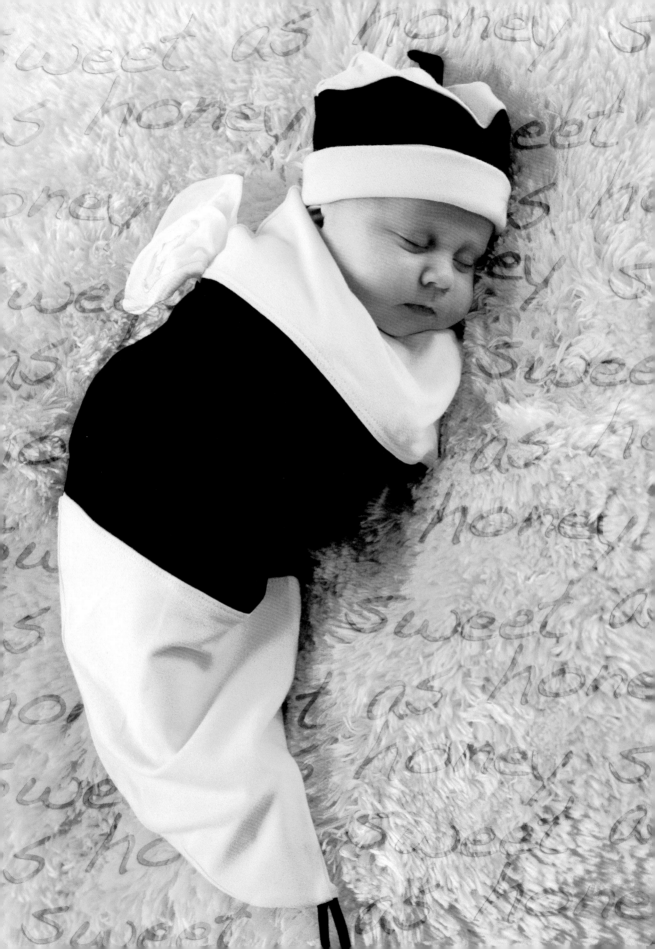

EIGHT THINGS TO AVOID WHEN DESIGNING A WEB SITE

1. **New Domain Names.** Google has implemented an aging filter. Any brand-new domain name is added to what is called the "sandbox." You can expect to wait nine to twelve months for a web site to be released from the aging filter. Only then will it begin to see good search engine results for competitive search phrases.

2. **Framed Web Sites.** Remove the frame structure from your web site. Most search engines struggle to extract information from a framed web site. Another danger of frames is that a search engine may send a visitor to the content frame without the menu frames, making it impossible for them to navigate the site.

3. **Flash-Only Web Sites.** Search engines can't index Flash-only pages. It's okay to use Flash components *within* an HTML web site, but your key phrases must be included in the text of the HTML page. Any key phrase(s) within the Flash will be ignored by search engines. (We'll look at this in greater detail later in this chapter.)

4. **JavaScript Menus.** It depends on the structure of the menu, but often JavaScript does not allow the search engine crawlers to pass on to the succeeding pages—therefore all pages can't be indexed and ranked.

5. **Duplicate Content.** Do you have your web site content duplicated over various domain names? Search engines deal with duplicate content differently, but the most common method is to direct viewers to the oldest and highest ranked version. The other duplicate versions do not appear in the search results.

6. **Hidden Text.** If you have text that is the same color as the background, or text placed out of the viewable area, you could be penalized. Avoid any hidden text.

7. **Bad Links.** Keep good company when getting links to your web site. Don't swap links with another web site unless you feel the site has good content. If a web site is just full of links and keywords, stay away.

8. **Unreliable or Slow Web Site Hosting.** If your web site is not available when the search engines attempt to crawl it, you won't get into their database. Use a quality web site hosting company.

by Michael Cooney (www.fearlessindustry.com)

changes for web sites that bear no significance to your web site (for example, when a baby photographer links to a travel directory). Because the content is not relevant, links from these sites won't be given much weight.

An easy way to ascertain whether a site is legitimate is to visit it and see how many links it has, whether they are similar in nature to your own, and what their Google PageRank is.

Not Recommended Practices. The following practices are not recommended.

Automated Directory Submission. Automated directory submission services have a reputation for submitting to low-quality sites. Manual directory submission is recommended.

Paid Links. Google has identified high-ranking web sites that obviously sell links for the purpose of increasing the buyer's web site ranking. In these cases, Google will discount the value of that paid link substantially. This method currently does not result in a penalty but does not produce the positive results it previously generated. It is fine to purchase links for the purpose of advertising, just not for link-building.

Any technique that is deemed an attempt to manipulate the results of search engine rankings can result in a penalty and should be avoided.

White Hat Techniques. White hat techniques are built to last and provide longevity to a web site's ranking. They are visible for humans to read and work with the permissible practices of search engines. The following are some examples of white hat (or good) techniques to use to better your web site's ranking. Others are discussed throughout this chapter.

Make sure that what you see with your eyes is what search engines will see, too. Avoid hidden content.

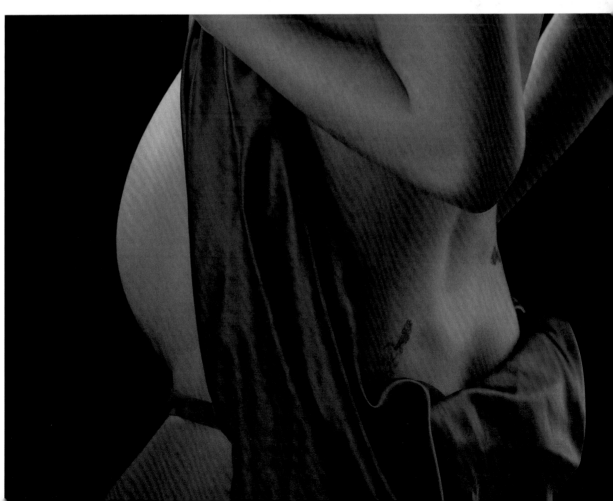

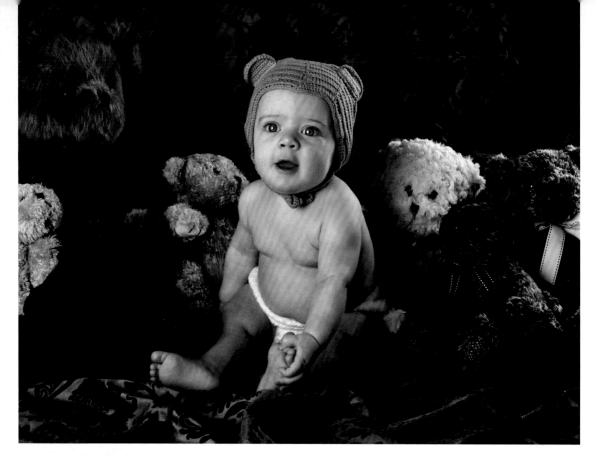

Good, Unique Content. Writing relevant and fresh content, and using your specific keywords within that content, is an important way of boosting your site's ranking.

Using Keywords in Each File/Domain Name. Naming your page and your heading the same as your keywords effectively improves ranking.

Add Real and Relevant Links. Building real and relevant links to your web site improves your ranking. Establishing reciprocal links with other relevant sites also provides your web site with a better ranking—especially when the other sites are in a related industry. For example, as a baby photographer, sharing reciprocal links with a baby clothing boutique, a parenting web site, or a children's bookstore could enhance your ranking.

LET'S TALK ABOUT FLASH

Many photographers purchase purpose-built templates for Flash web sites with the idea that this will most effectively showcase and highlight their photographic work. Unfortunately, there is a big disadvantage to using a web site completely built using Flash:

ABOVE AND FACING PAGE—Add keywords (such as "baby photographer") to your images to describe them.

A NOTE ON METATAGS

Hidden content like metatags are not visible to web site visitors. Therefore, Google does not use this type of keyword data. The metatag description will be picked up in the search results but are not ranked as being as important as the content users actually read.

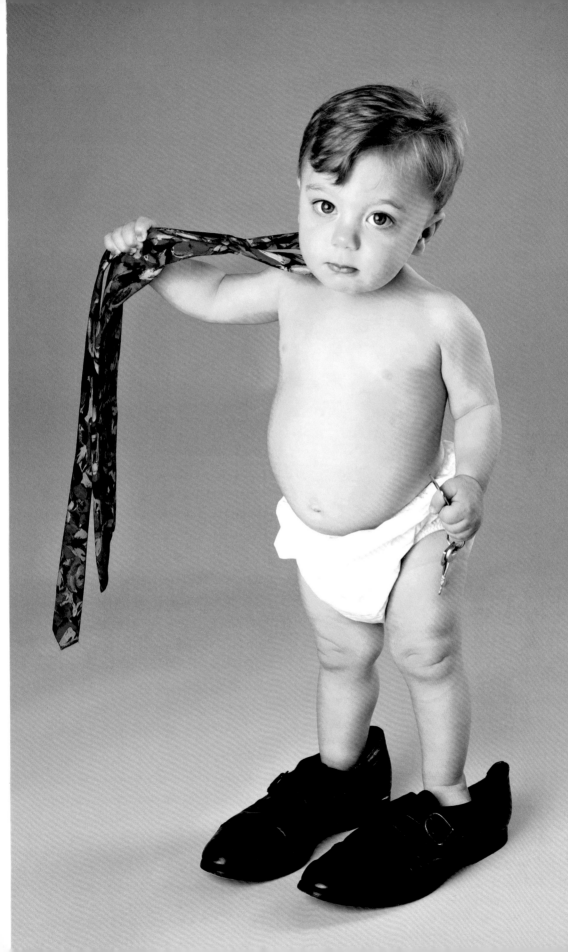

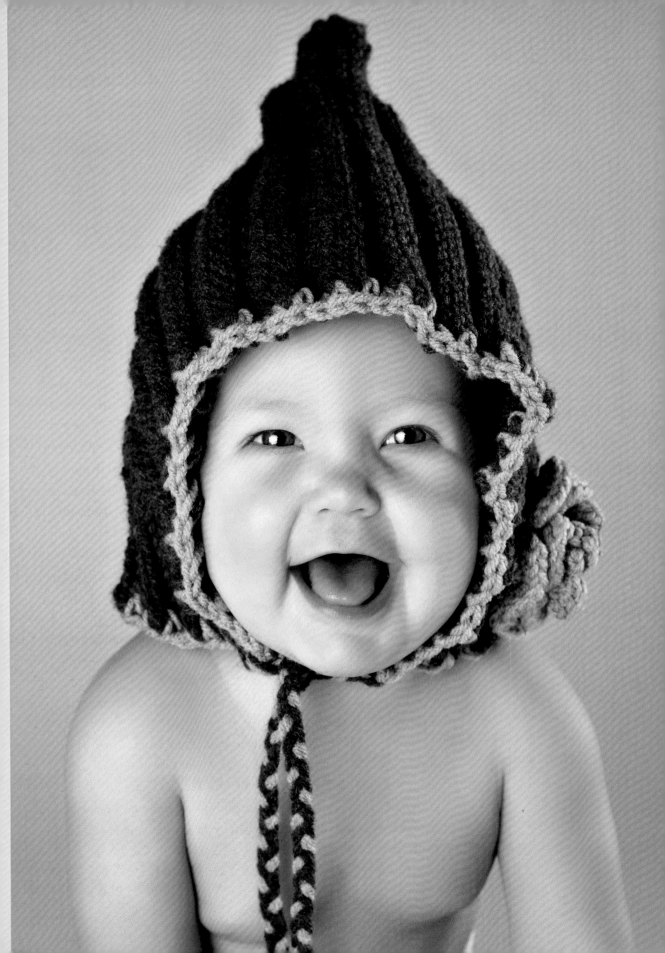

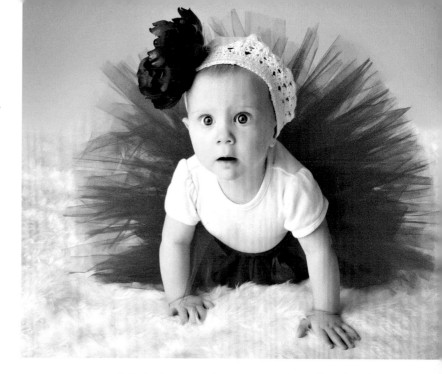

OTHER WAYS TO INCREASE TRAFFIC

Pay-Per-Click (PPC) Campaigns. A PPC advertisement is paid advertising based on keywords and their industry value. You pick the keywords and decide how much you are willing to pay the host web site for each person who clicks on your online ad.

You also determine the location (global, national, or local) of users you want to target, as well as the length of time you want your campaign to run. It's advisable to set an expiry date when you first try it out so that you don't run up a huge bill; automatic charges for this service will be made to your credit card. The beauty of this type of advertising is that you can make adjustments while the campaign is running, giving you more control and a far more affordable option than other mediums of online advertising.

Google is widely known for its PPC service called AdWords. Once you have your Google account set up, you can opt to try out AdWords as a means of driving traffic to your web site. The AdWords advertisements are usually placed to the right of the user's search results as either text alone or text and images. Microsoft adCenter and Yahoo Search Marketing recently combined efforts to shows ads on both Yahoo and Bing. This gives us another avenue to explore so that we can cast a wider net when it comes to attracting web site traffic.

Directory Advertising. Paying for listings on free or paid directories can be useful if they are specific to who you are targeting and how you want to enhance your branding. In the wedding industry, directories are a popular form of gaining traffic and exposure (getting a listing on www.theknot.com, for instance, can be useful). In the baby photography field, I've found that things are a little different.

In general, moms need to hear about your company several times before they gain enough trust to call. Therefore, for baby photographers, directory listings don't tend to generate many direct referrals. Instead, they serve primarily to enhance where your web site appears in the natural

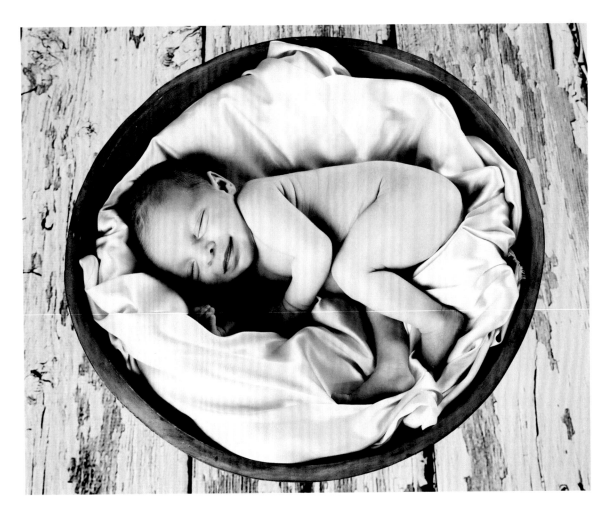

search results of Google, Yahoo, or Bing. Branding is everything and the more visible you can make your company, the more appeal it gains in the eyes of potential customers.

The bottom line is this: directories that are specific to your niche work great for building your brand, but you still need to keep up other forms of marketing to gain measurable results.

The Yellow Pages. Many cities have a Yellow Pages directory where you can place a print ad. In my opinion, however, unless they also provide an online directory, it's a waste of money. Print-only directories are quickly becoming extinct (not to mention pricey) because they offer only "chance" visibility. Unless your potential customer happens to pick up the paper directory, page through it, and land on your advertisement, the results can be very disappointing. Besides that, once it's printed, you can't make any changes to the listing. That makes it a restricted and expensive medium.

When a visitor arrives at your site, they need to see quickly what your company is all about.

NINE TIPS FOR BETTER WEB SITE DESIGN

These tips are for companies with a web site intended to increase sales, generate inquiries, and create orders for their products and/or services.

1. **Enhance Your Homepage.** Your homepage is the doorway to your web site, so make the most of it. When a visitor arrives at your site, they need to see quickly what your company is all about. If a visitor can't tell what you do from your homepage, they will proceed to another site. Provide links to all your important products and services.

2. **Streamline Your Web Site's Structure.** Structure your site so that it is easy for visitors to find the information they want. Minimize the number of clicks needed to reach all your important information.

3. **Offer Easy Navigation.** Navigation is part of a good web site's structure. Make sure visitors can find information—but don't forget that people may first arrive at a page deep within your site. Ensure that visitors can quickly navigate to your homepage (and other major sections) from *any* page on your site.

4. **Use a Uniform Page Layout.** Employing a consistent structure for each page makes your site more appealing. Start with a page title, heading, picture of products and/or services, overview paragraph, typical application section, sizes, specifications, etc.

5. **Look at Landing Page Effectiveness.** When a visitor uses a search engine to find your web site, they will be sent directly to the most relevant page within the site. Therefore, you need to make sure that each and every page does the best job it can to inform new visitors about that specific product or service. Provide good information, make it clear how to contact your company, and offer a way to navigate easily to other pages on your site.

6. **Provide Good Content.** Offer enough information about your products and services that visitors can potentially place an order or make a purchase based on it. Alternatively, give a good introduction to your products and services, then make it really simple for them to make contact with you.

7. **Supply Easy Contact Information.** Make your contact information easily accessible. Some people like to talk to someone before ordering or just need more information. Many people want to deal with someone local rather than someone overseas and this can mean the difference between getting an inquiry or not.

8. **Pay Attention to the Speed of the Web Site.** If your web site is slow due to big files sizes and Flash-driven pages, it is going to frustrate potential customers. Keeping file sizes to a minimum is good practice. Your hosting company should also be fast and reliable. *You* may have a super-fast Internet connection, but there are plenty of potential customers who still don't have access to a high-speed connection.

9. **Make a Great First Impression.** Is your web site visually appealing? A web site that looks like it was designed by an amateur who put very little effort into the content suggests to visitors that the company can't be very successful—after all, they couldn't even spend a bit of money to have a decent web site designed! It doesn't take a lot to get a professional-looking web site. If you can get your product and service information together, half the job is already done. All you need then is a professional-looking logo, some good pictures, and a decent web site designer. Pretty soon, you've got yourself an attractive, high-quality web site that gives visitors a great first impression.

by Michael Cooney (www.fearlessindustry.com)

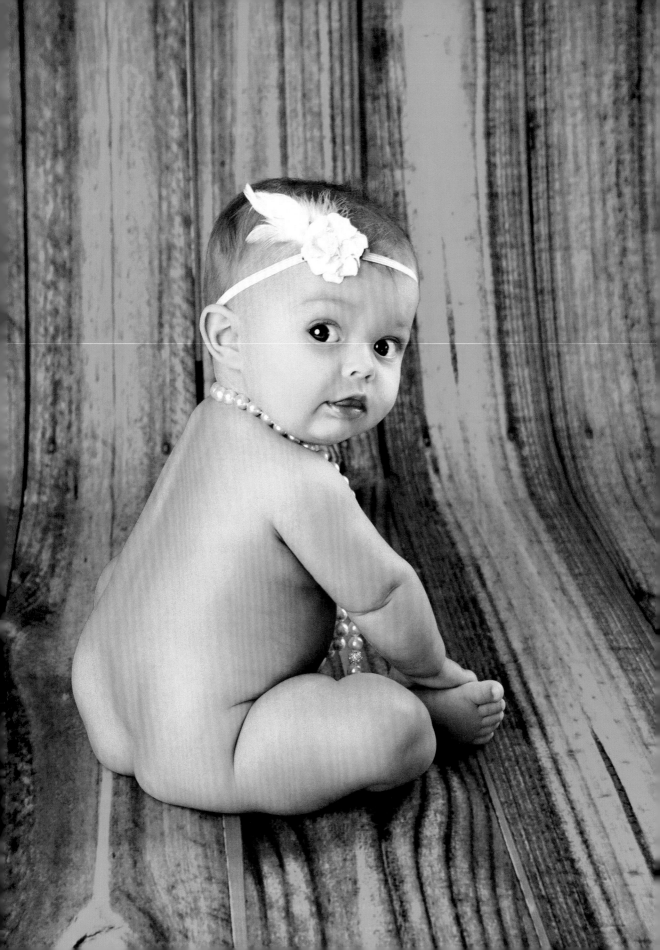

5. MARKETING THAT WORKS

"The critical ingredient is getting off your butt and doing something. It's as simple as that. A lot of people have ideas, but there are few who decide to do something about them now. Not tomorrow. Not next week. But today. The true entrepreneur is a doer, not a dreamer."—*Nolan Bushnell*

With the advent of the Internet and the accessibility of many free tools, it's become easy for new businesses to gain traction in a relatively short amount of time. We can now reach out to potential customers in an instant; with every click of our mouse, we can spread the word and spread it fast. This chapter covers some of the many mediums available for you to leverage your marketing message. Of course, there are many more—and the speed at which things are changing makes it nearly impossible to cover it all. These are some techniques you can use right now, and best of all, they will cost you little or nothing.

SOCIAL MEDIA

Business is personal; we buy from those we like and trust. As businesspeople, we create trust among our friends and clients by being honest, open, caring, and upbeat. Using social media allows us to communicate these aspects of our personalities far and wide. Not everyone will care what you had for breakfast, but the more you share about yourself and your company, the more endearing you become. As your "friends" and "followers" read about and comment on your day-to-day activities, it fosters a sense of loyalty among them. (Of course there is a line that can be crossed. You don't want to create a perception that you're a narcissist, so don't make it all about *you*. Share what means the most to you, what moves you, or what inspires you. Avoid the self-indulgent "look at me I'm so great" approach.)

Facebook. If you don't have a Facebook profile you must be living under a rock! Get with the program and create an account

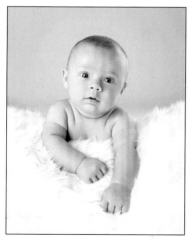

ABOVE AND FACING PAGE— Business is personal; we buy from those we like and trust. As businesspeople, we create trust among our friends and clients by being honest, open, caring, and upbeat.

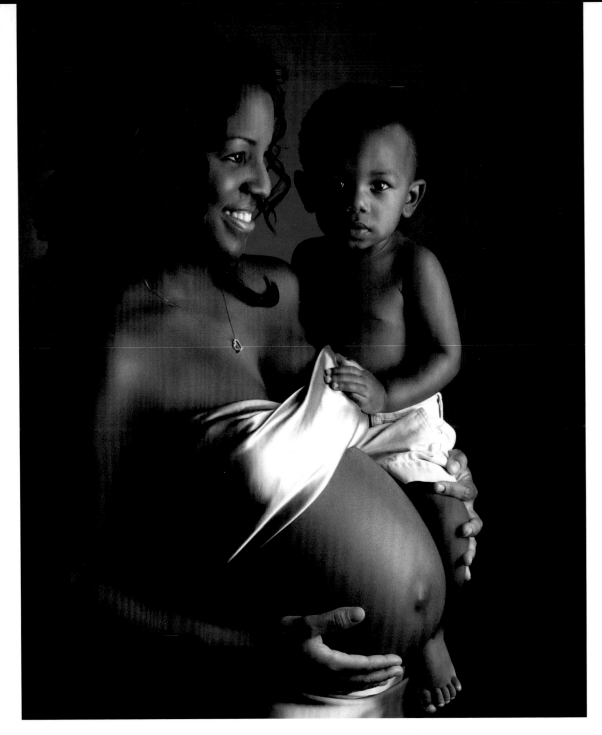

now—you'll be amazed just how quickly you can create a follow-ing. Facebook is run by real people, so it's constantly evolving to provide better service. In the rest of this section, we'll look at some of the aspects you'll find valuable as a professional photographer.

Facebook Profiles (for People). It's as easy as pie (not to mention free) to sign up for a personal account using your real name. This

ABOVE AND FACING PAGE—Moms love to share their experiences on Facebook.

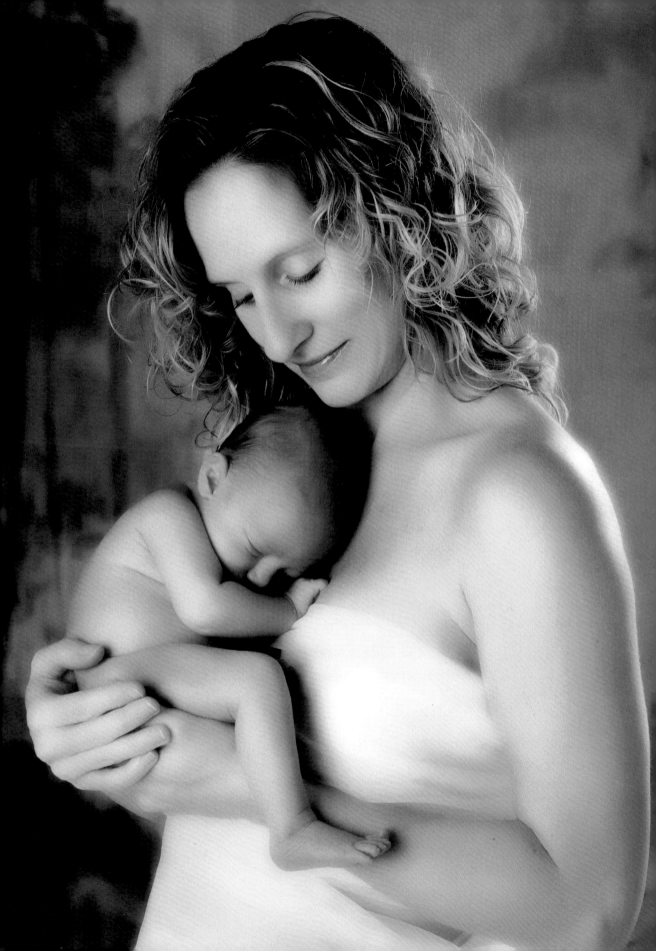

type of account allows you to add personal information, post photos, links, videos, and make personal comments. It's up to you how much or how little you wish to share; privacy settings let you set up your profile to avoid unwanted interactions or solicitations.

Once you've set up your profile, you can start connecting with friends by sending out friend requests. Facebook has a search bar you can use to find people, or you can let the FriendFinder software look through your e-mail address book for people you might know. Once you have acquired a few Facebook friends, you can extend your network by looking at *their* friend lists for common acquaintances. You'll also find that you start receiving direct friend requests, which you can choose to accept or ignore. (And don't worry—if you ignore a friend request from someone you don't know or don't wish to be associated with, they will be none the wiser.)

Setting up albums of photos is a great (and free) way to market your work—you can choose whom you want to share each album with. You may decide to make your personal family photos visible only to your family and to make your client photography visible to your friends, to your friends *and* the friends of your friends, or to everyone in the world.

Make sure you watermark your images when uploading them to Facebook. Once they are in an album, the file names are changed and it can be difficult to trace them back to you. Adding your logo and web address to each image will also deter any unscrupulous copyright offenders. Uploading only web-quality (72dpi) images will deter unauthorized printing of your work.

The beauty of sharing your photos on Facebook is the ability to "tag" the individual in the photos. Once uploaded to an album on your account, you can identify the client in each of the images—making the images automatically appear in the client's news feed. This is a wonderful way of promoting yourself using the client's network of friends; because you are directly linked to the images, you will receive an e-mail whenever any of the client's friends comment on them. Of course all the gushing about how wonderful your images are is a perfect way of getting feedback on your work—and testimonials! One thing to remember is that you have to approve your client as a friend through your own personal

Make sure you watermark your images before uploading them to Facebook.

This is a wonderful way of promoting yourself using the client's network of friends.

Facebook account before you will be able to tag them in your albums. This is a good reason to have both a personal *and* a business Facebook page. However, should you not be connected as friends, the client can still personally tag themselves and/or their friends in the photos you post.

The downside of combining your personal and professional information is that you have to be careful what you share and ensure you don't inadvertently offend anyone. Again, not everyone wants to know every little arbitrary detail of your life, so make sure your posts are worth reading. Avoid profanity, personal comments about other people, and links to distasteful sites. Remember: you are your brand and people will judge you accordingly.

Facebook Pages (for Businesses). Facebook Pages are particularly well-suited to individual artists and to businesses where an official member of the organization will manage the content and in-

Facebook makes it easy to build a network of like-minded people.

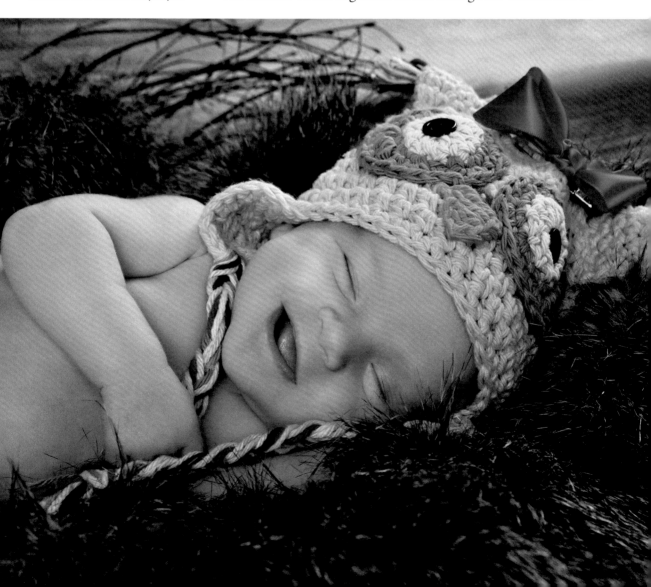

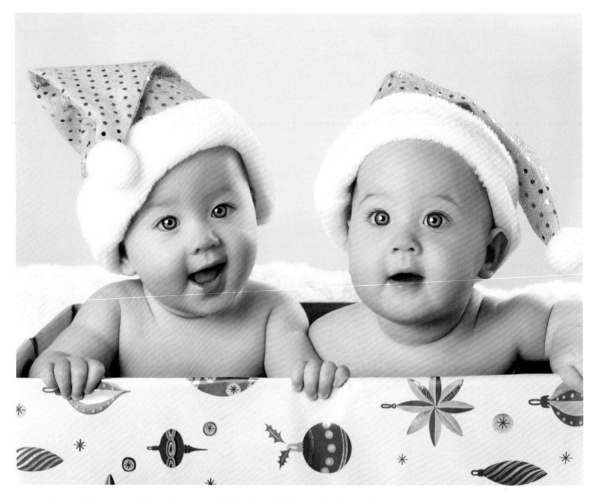

teraction with users. The beauty of Facebook Pages is that they are completely public—meaning that a Facebook account is not required to view them. If someone enters "baby photographer Texas" in their search engine, they will come across your Facebook Page as a web link.

ABOVE AND FACING PAGE—No matter the size of your business, you have the potential for exponential growth among users if you engage their interest.

If the visitor *does* have a Facebook account, they can click the "like" button at the top of the Page to be added as a fan. Then, every time you add a post or advertise your services, an alert will appear in their Facebook news feed as if they were one of your friends. This makes it easy to build a network of like-minded businesses or people.

As an administrator of the Page, your posts will appear to come from the company name itself, not from you as an individual. This provides some anonymity; anyone you make an administrator, whether it's a friend or an employee, could have posted the com-

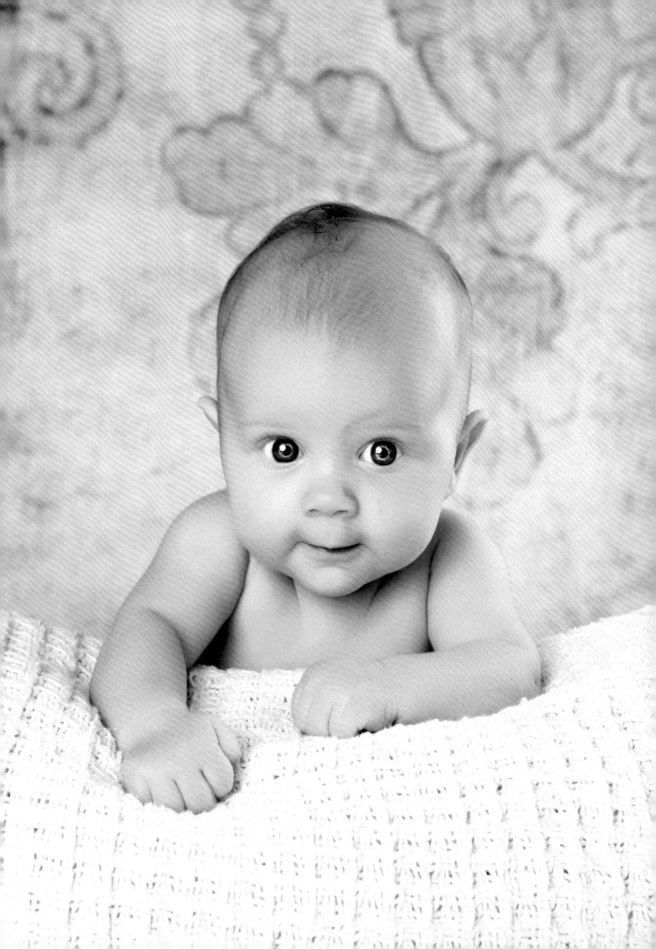

Here's what my blog looks like.

ment. Another benefit is the insight tool that is e-mailed to you regularly. This provides statistics on how many people have viewed your page, demographic information about those viewers, and details about visitor interaction with your Page. No matter the size of your business, you have the potential for exponential growth among users if you engage their interest.

Facebook Groups. The difference between a Page and a Group is that Groups can be created by anyone—not just by the business owner or artist, but by fans themselves. Groups can be about any topic and provide a forum in which to share opinions about that common interest. Groups can be public (open to anyone on Facebook) or private (so that only invited guests can become affiliated with the group). As the administrator of the Group, your name appears on the Group and the content you post on the wall will appear to come from you as an individual.

Facebook Applications. There are several applications available that can improve Facebook's interactivity. One application I love is called NetworkedBlogs (www.facebook.com/networkedblogs). This app networks the new posts you make on your blog and on Twitter so that they appear as posts on your Facebook profile, too—this means you can do three things at once, making you more efficient. The more efficient we can make things, the better our bottom lines will be.

Blogs. Blogs have become a must-have trend in recent years. While web sites usually have to be updated by a site designer, many of the blog platforms provide a DIY (do it yourself) option. Be-

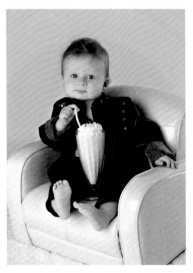

Regularly posting your favorite new images will entice people to visit your blog more frequently.

cause additions are so easy to make, blogs let Internet users learn about you and your business in the most up-to-date fashion. Having a web site will always remain important; it performs the role of your storefront. Your blog, on the other hand, acts like your salesperson within the shop. As noted, people buy from people they like, so the more likeable you can make your blog, the better it will be for your business.

There are many blog platforms available. Some popular ones are WordPress (www.wordpress.com), Blogger (www.blogger.com), Blogspot (www.blogspot.com), and Tumblr (www.tumblr.com). Each has its own advantages and disadvantages that need to be accessed on the basis of your needs. Generally, the blog platform is free, but there may be extra features available for purchase. WordPress is my personal favorite, since it lets you purchase compatible themes that are well-suited to photographers (check out the ones

Tweet about your favorite images.

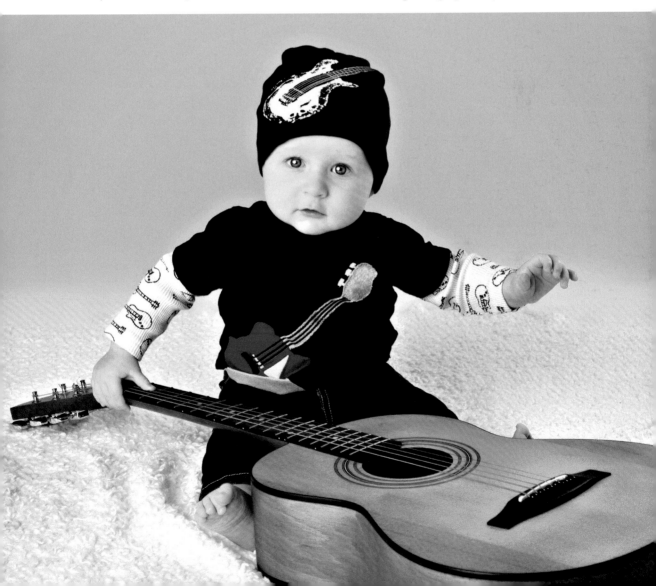

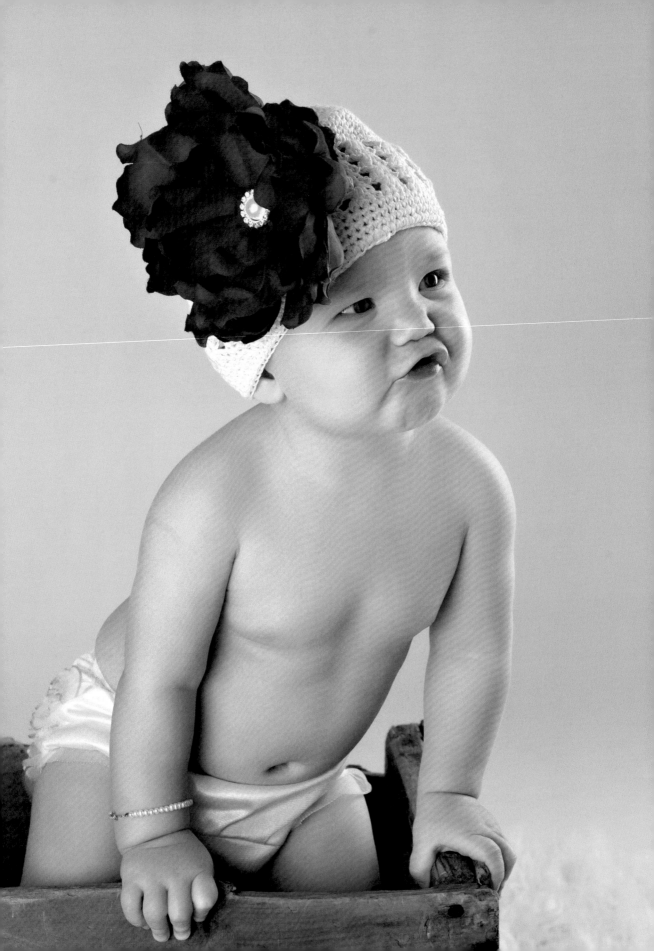

FACING PAGE—Providing an incentive is a key factor in getting people talking about your work.

from NetRivet at www.netrivet.com). If you see a blog you like, scroll to the very bottom of the page to see who the provider is. You can then click their link to learn more. As photographers, our images need to speak for us, so pick a platform that allows you to easily update your content, upload large-sized images, and view them with crisp quality.

Also, be sure to choose a blog platform that is search-engine friendly so that your posts will be indexed by search engines. There are plugins available to make this more efficient; to find some options, search in Google for "blog search engine optimization."

Twitter. What are you doing now? This is a simple question, but if offers an effective and meaningful way to communicate with existing and potential customers about who you are. This is the basis of Twitter, a free platform that allows you to attract followers with similar interests.

There are software products available for purchase (such as Tweet Adder) that make it easy to connect with people on Twitter—but while these programs ensure that your follower numbers stack up pretty quickly, they don't necessarily produce quality networks. There are some Twitter diehards whose aim seems to be attracting as many followers as possible in attempt to win the numbers race. This can work if your aim is to attract a broad range of eyeballs who may potentially be interested in your service or product. As boutique photographers, however, we provide a personal service, so I don't believe sheer numbers are very beneficial. If you're aiming to attract po-

tential clients to this kind of business, the quality of your contacts matters much more than the quantity. (Of course, if you want to build a celebrity following of random names, then go right ahead—stack 'em up!)

Twitter also allows you to link your account to your Facebook account so that posts you make on Twitter are automatically posted to Facebook. This is another great time-saving feature.

THE WOM EFFECT (WORD OF MOUTH)

As any business owner knows, the best business comes from referrals, or word of mouth. Best of all, business leads from WOM don't cost a single advertising dollar! People who come to you through WOM are already qualified, meaning that you have already broken through the first barrier of sales: fear of the unknown. Trust is everything and if their friend trusts you and recommends you, you are halfway there.

To effectively get the "talk engine" moving, you need to provide tools to facilitate it. At our studio, every order includes a set of personalized business-card-sized brag cards featuring the client's favorite image from the session. On the back of the card is a thank-you incentive; we offer a $100 gift certificate for both our client *and* his/her friend when someone they referred books a session. Having tried different certificate amounts over the years, we've concluded that you need to offer a substantial incentive before your client will be motivated to share. Some clients will absolutely love you and talk about you no matter what you offer—but not *every* client is as outspoken as these gems, so you need to give every client a reason to gush!

E-MAIL NEWSLETTERS

If we don't regularly remind our audience who we are and what we do, they will soon forget—as the saying goes, "Out of sight out of mind." Competition is fierce; if we aren't in the forefront of our potential and existing clients' minds, they can easily be stolen away by the competition.

To accurately manage your database of e-mail contacts, you need the help of software to do the sifting and checking for you. It would be a very time-consuming task to individually add the e-mail address of every potential, past, and current client to your e-mail program. Happily, there are companies that provide storage and management systems to make things far easier for you. My favorite is Constant Contact (www.constantcontact.com), which offers a free trial period so you can try before you buy. There are different pricing structures based on the number of contacts in your database. (To earn yourself a $30 credit when you sign up for a Constant Contact account, make sure you mention "PhotoLyrical"; it will be added to your account through the "refer a friend" incentive they offer.) Constant Contact has a strict no-spam policy, so you will need to ensure that your list is verified. If you just purchase a database of unknown addresses, you will encounter spam problems and have your account frozen.

The best, most accurate way of building your e-mail list is to provide a link on your web site so users can choose to add themselves to your list. The second-best way is to manually add each individual client's e-mail address to your database when you encounter them. There is no fast way to build an accurate, reliable, and productive database; you just have to expand it one name at a time.

PRESS RELEASES

Make some noise in your local media about what you are up to—your work with a charity, an award you won, or a workshop you are teaching. Editors like to feature local stories, especially if they are written for them and come with pretty photos to illustrate the story. Writing a press release is not as hard as you think; just keep the following guidelines in mind.

Make sure your subject or title is catchy and grabs attention. Think of a play on words, a

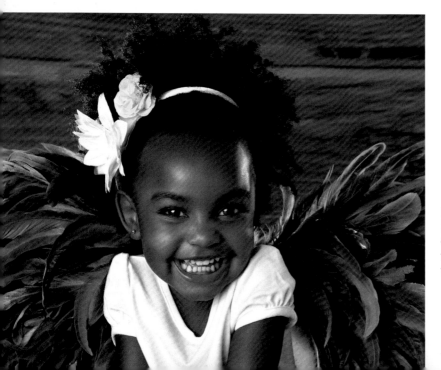

LEFT AND FACING PAGE—
Editors like to feature local stories, especially if they are written for them and come with pretty photos to illustrate the story.

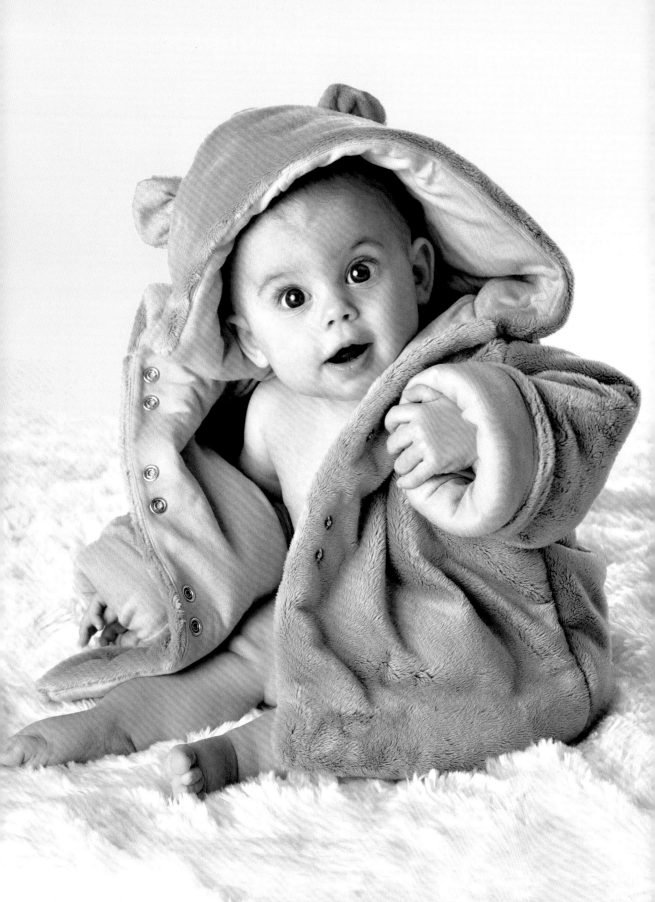

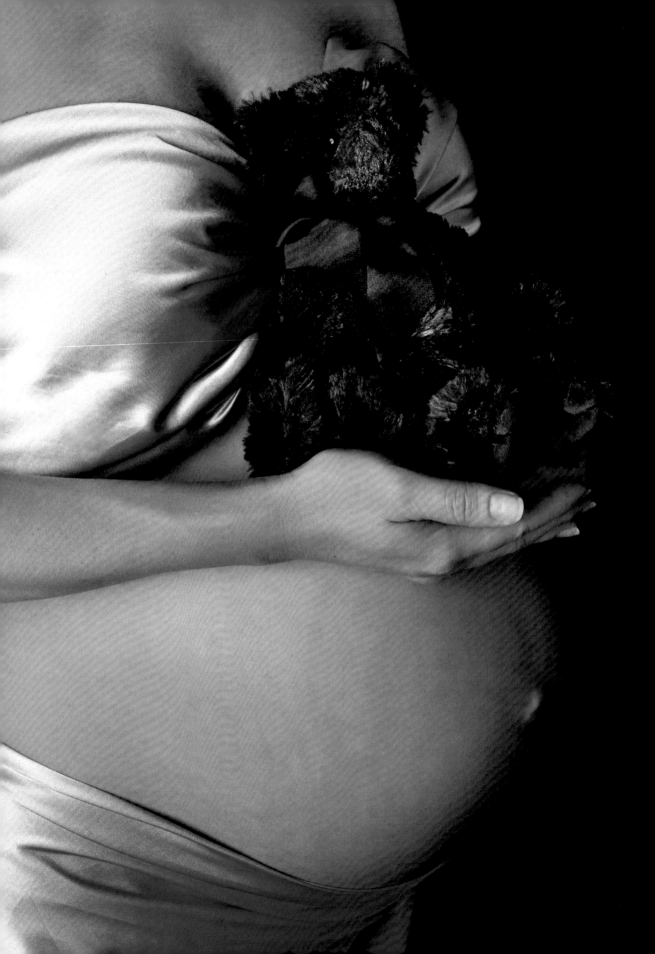

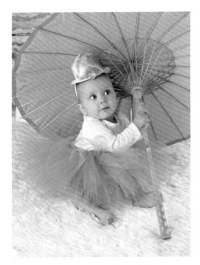

ABOVE AND FACING PAGE—
Tantalize the reader so they'll be excited to read the whole news article

grand statement, or words that evoke emotion. Also, make sure you have a beginning, a middle, and an end to your story. Your first paragraph needs to provide a summary so that editors can decide if it's newsworthy without having to read the entire release (remember, editors are busy people). Tantalize the reader throughout so they'll be excited to read through to the conclusion.

If you're trying to elicit a response, ensure you have a call-to-action statement like, "Visit www.yourwebsite.com," or "Call (800) 555-5555." Don't forget to include your contact info, web site address, and e-mail address.

Send out your release by e-mail without photos first so that you don't clog up the editor's e-mail account. Be sure to note, however, in the body of the release that you can provide photos.

Be persistent and send out your release to as many media contacts you think apply (television, newspaper, radio, blogs, etc.). You may need to send it more than once to get a response, so don't give up after one try. It's always nice to follow up on an e-mailed release by making a short phone call to introduce yourself and establish a personal connection.

BUSINESS CARDS

Your business card is kind of like underwear: you shouldn't leave home without it! Make sure that it is legible, that it features high-resolution photos, and that it provides all of your contact infor-

Always keep business cards handy.

mation in an-easy-to-read font. This may be the first connection potential clients and business associates have with your company brand, so make sure you use nice card-stock and have them printed professionally—avoid the in-home ink jet printer! There are many affordable print options available on the Internet that provide a quick turnaround—VistaPrint (www.vistaprint.com), White House Custom Color (www.whhc.com), and Miller's Professional Imaging (www.millerslab.com) to name just a few.

PUBLIC DISPLAYS

Often, people can't imagine how their child would look in a professional photo. It's only when they see something that inspires them that they say, "I want that!" Providing wall art to be displayed in public places (such as hospitals, doctors' offices, and boutique stores) is a great way of exposing your work to some people who would not have gone out of their way to find you otherwise. These businesses will usually be grateful for artwork to decorate

Often, people can't imagine how their child would look in a professional photo.

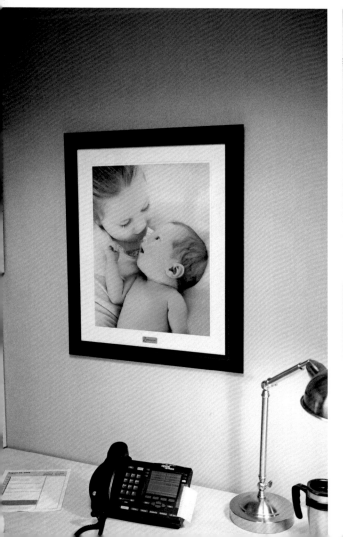

It's only when they see something that inspires them that they say, "I want that!"

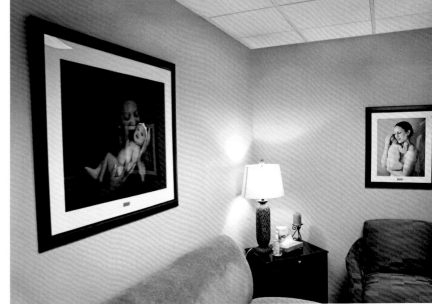

their walls and happy to offer your business card to those who inquire about it. The best way of opening the door to this type of opportunity is to approach it as a donation, which means you will have to cover the costs of putting the pieces together. It's vital to keep regular contact with the individual you have built the relationship with in order to maintain their high level of enthusiasm for your work.

6. THE OPERATIONAL PROCESS

"When you're taking care of the customer, you can never do too much.
And there is no wrong way if it comes from the heart."—*Debbi Fields*

I love going to the spa. The moment I step through the doors, I'm welcomed by the fresh aroma of scented candles, the warm lighting, and the friendly faces. The simple touches are the things I remember—like the freshly brewed coffee, the ice-cold water in

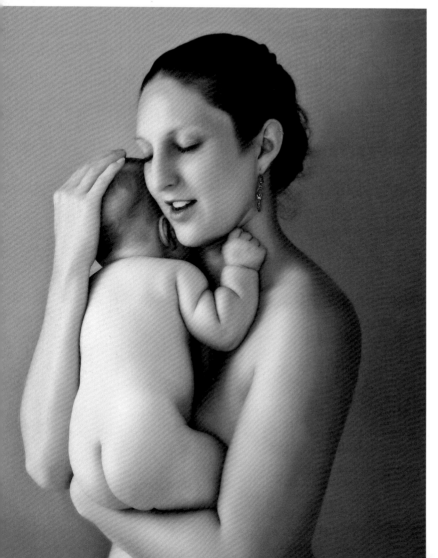

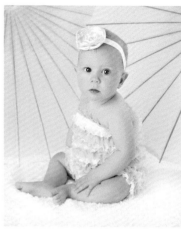

**ABOVE, LEFT AND FACING PAGE
TOP**—Images should be designed
to make an impact

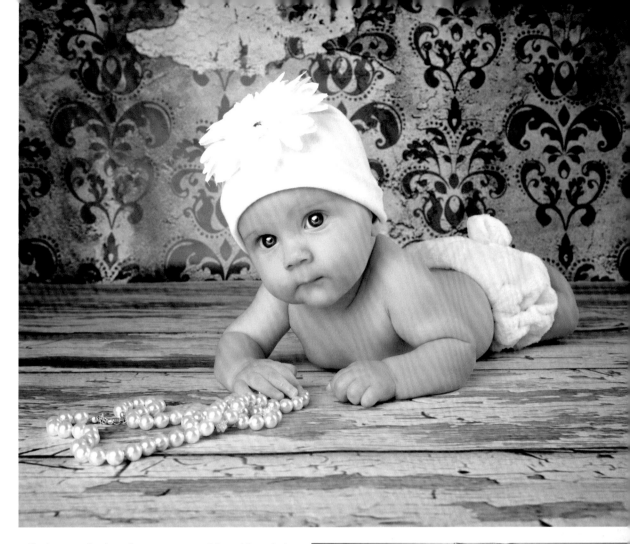

tall glasses, the bamboo-encrusted hand bowls in the restrooms, and the oversized comfy chairs. I eagerly look forward to the experience, because I know I'm going to be treated like a princess. Of course I *also* know I'm going to pay a pretty penny for this service—but, hey, I know I'm worth it! A trip to the spa makes me feel special. That's how your clients should feel about their experience at your studio.

A Few Basics

There are a few basic factors that may seem like common sense, but they play an important role in creating a positive experience for both you and your client.

The entrance area of my studio.

Keep It Tidy. Keep your studio area clean, fresh, and inviting. Use lighting to create a relax-

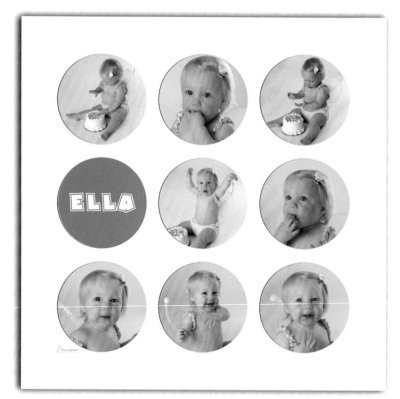

LEFT—Collages are always a favorite product.

BELOW—Customized leather and fabric albums.

ing mood. Add room scents for that fresh feeling—and don't forget to provide comfortable furniture for your guests.

Stimulate the Senses. Offer freshly baked biscuits or cookies, individually wrapped snacks for the kids, and chocolate for the adults. Branded water bottles are great for that special touch. A treat box full of sweets or candy is a definite must that acts as a great incentive for kids (more on this in chapter 9).

Remember Names. Dale Carnegie said that a person's name is the most important sound in any language. Remember your client's name, and the names of their children and spouse. When talking with them, using their names is an easy way to show that you care.

Consider Your Body Language. Keep your legs uncrossed, face your hips toward the person with whom you are speaking, ensure your hands remain open (not clenched), and tilt your head in the same direction as the person you're engaged with. This immediately creates a strong sense of empathy.

Consider Your Attire. Wear coordinated outfits, clean shoes, and accessories for a stylish, professional look. The way that you present yourself is an indication of what the client can expect from your company, so make sure your first impression is a good one.

Offer Something Different. Photographers are a dime a dozen. To make yourself stand out from the crowd, go the extra mile and offer a complete service. Simply handing over the images on a CD or printed on photographic paper just isn't enough anymore. Everyone else does that. Instead, consider hand-painted frames, custom collages, photo jewelry, metallic paper finishes, leather albums, etc.

Use Packaging to Please. No matter what the client has ordered, keep your presentation and packing consistent with your brand. Use ribbons, bows, boxes, and handwritten thank-you notes for that boutique feel.

Remember Excellent Customer Service. This is a major factor in separating the men from the boys. Provide immediate follow up after a client has picked up their order to make sure they are happy with their purchase.

A PROCESS THAT WORKS

Clients look to professionals for advice, guidance, and expertise. It's important to remember that you are the expert. You need to be in control of the situation. If you are, your clients will feel comfortable that they are in good hands. You need to guide them gently through the process and educate them so that, in the end, you have a very happy client who is eager to sing your praises.

The colors in this portrait were selected to match the baby's nursery.

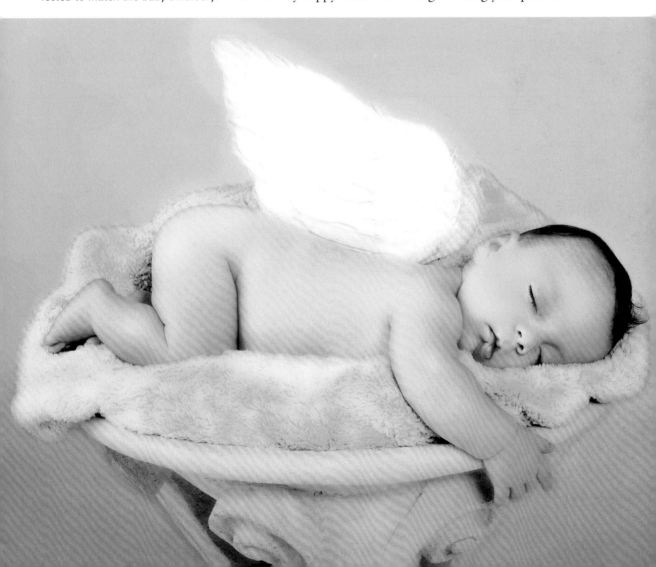

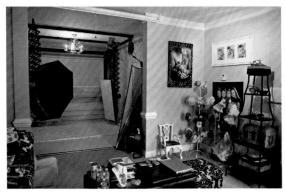

A view into the shooting area/dining room.

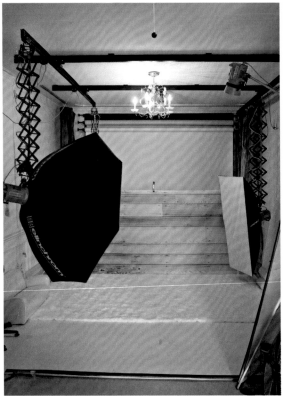

My track lighting system.

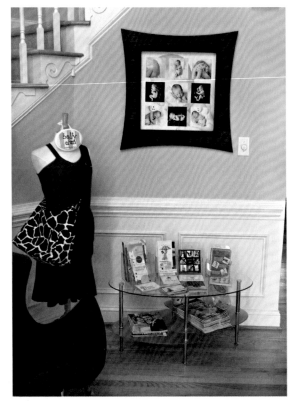

The first wall art my clients see as they walk in the door.

Hand-painted frames are a beautiful, personalized product.

There is a five-step process to use when dealing with a client. If followed correctly, this will prevent any issues down the line regarding expectations and price. One of the worst things that can happen is sticker shock—where the client is horrified at your prices and disappointed that they went to the effort of having their photos made. Never take on a job without first educating yourself about the individual client's needs and educating the client about what it is you offer.

1. The First Interaction. Your first contact with a client will most often be by telephone or by e-mail. Courtesy and friendliness set the tone for a positive interaction. In order to determine

if your advertising dollars have been well spent, it's important to ask how they heard about you. You may offer a discount or incentive if they have been referred by a friend, creating a sense of generosity even before they have worked with you.

Ask questions about the client's interests and needs. Ask about their children. Or if this is their first baby, ask whether they have picked out their nursery colors yet, etc. If they have viewed your work on your web site, find out what images inspired them to call. Talking through your web site while you have them on the phone will help you direct them to appropriate ideas and get them excited.

Throughout your interaction, using phrases like "You're going to love . . ." and "We are here to guide you . . . " will enforce a positive mind set. As Dale Carnegie said, "Get the other person saying 'yes, yes' immediately." To do this, ask questions that encourage a positive response. Keep your tone of voice upbeat and get them excited about you by *being* excited.

Once you have their attention, explain how things will work and get them to commit to an appointment immediately; telling them you will send an e-mail with appointment options only introduces delays that result in lost interest. Stay in control of the conversation by offering either/ or options, such as, "We have appointments available on Monday at 10AM or at 12PM. Which would you prefer?" Once you have all their contact information, explain that you will send an e-mail confirmation of the appointment date, and that you will include your contact information as well as a map with directions to your studio (or other meeting place).

2. The Design Session or Consultation. It is a mistake to commit to photographing a client without first consulting with them. How will you know what their likes, dislikes, tastes, and budget are if you go straight to the session appointment? Without pre-planning, you and your client will experience misunderstandings and disappointments that could easily have been avoided.

Our framing room displays many available options.

We provide a changing table for babies.

Some photographers call this pre-shoot meeting a consultation. I prefer to call it a "design session," because this conveys that a commitment is required and that this meeting is part of the planning process. During your time with the client, it's important to explain things such as what they need to bring to the session, clothing options, the time commitment required, product choices, package options, payment facilities, and your cancellation policy. If you offer installment payments, mention it now; financial issues may be a barrier to commitment that your client is too embarrassed to talk about.

It is ideal to have the client visit your studio space so that you can walk them around and show them what your finished pieces look like hung on the walls. Very few people can accurately determine sizes, so don't assume that your client knows how big a 16x20-inch print looks on a wall. Having them touch and feel your products is a great way to get them involved. People are better at remembering the tactile aspects of any experience—so show, don't tell. Getting them excited by showing them examples of beautifully finished art pieces paves the way to higher sales

later on. (*Note:* If you are not able to meet in person, take the time in your initial telephone conversation to outline step by step the services that you provide and explain what your expectations are of the client.)

As you talk to the client, you can reinforce the boutique sensibility by using terms like "quality," "caring," "custom," and "hand-made." Add trigger words to convey your high standard of quality and expectation of a higher investment: "design session," "our expertise," "planning," "heirloom art," "wall art," "art pieces," "my advice is," "complementing," "contrasting," "wall décor," etc.

During your conversation, make sure you cover your background options, clothing, props, and lighting selections so that you know what style and lighting setup you need to prepare for. Make notes of your conversation so that you can refer to it later. With so many clients, it can be hard to remember the exact preferences of each one.

Finally, give them something to take home as a visual reminder of your meeting so that they will remember what you talked about. At my studio, we give each client a goodie bag before they

An actual client's nursery shows the hand-painted frame we created for it.

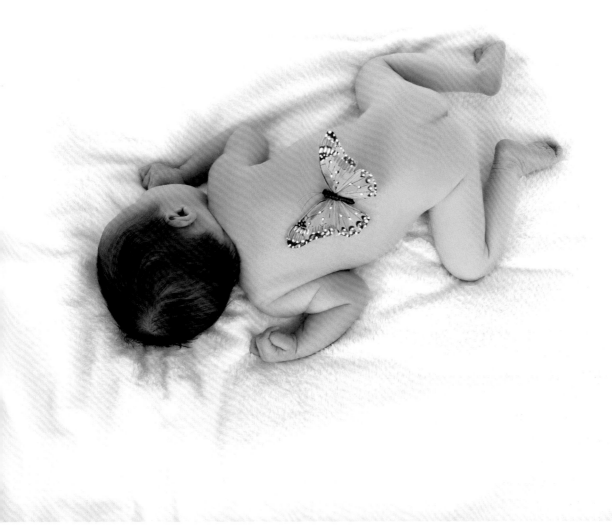

This art piece was created to coordinate with the baby's butterfly-themed nursery.

leave. This contains our price menu, promotional offers, appointment reminders, wall décor planning worksheet, a measuring tape, a pen, branded chocolates, and discount coupons from other vendors we love (clothing boutiques, etc.).

3. The Photo Session. Hopefully you built enough excitement about the session during the consultation that your client is looking forward to spending time with you—but it's still a good idea to send a reminder of the appointment the day before, just in case they have forgotten. Being stood up is very annoying and costly, since it's hard to fill an appointment at the last minute.

Before they arrive, set the mood by having soft music playing. Check that the scent in the room is inviting, set up refreshments and snacks, and use overhead lighting to illuminate your artwork

for a gallery effect. Welcome the client warmly, help them retrieve their stuff from the car, and explain where the changing rooms and refreshments are located. Making them feel like welcomed guests creates a warm environment.

Your pre-planning will have allowed you to prepare the studio or shooting area with the correct equipment so that you don't spend time fiddling with gear in front of the client. This is especially important when it comes to photographing kids. Throughout the shooting process, use positive and encouraging words so that they feel good about themselves. Their genuine enjoyment will be evident in the images.

This is where your personality and enthusiasm for what you do really needs to shine through. It often feels strange for the ordinary person who is not a model to pose in a way that is flattering for photographs, so explain that even though it feels weird it looks good! Showing them the images on the back of your camera a few times during the session gives them an instant visual so that they get excited about their progress. Often, it encourages the client to get more enthusiastic

and make adjustments themselves to how they are posing.

For new moms, seeing their baby on the camera's viewfinder is a fabulous way of building their excitement for their next appointment: the ordering appointment. Add to this excitement by saying things like, "This is going to look wonderful above the baby's crib," or "This is perfect for over the fireplace." These suggestions put a picture in their mind's eye and plant the seed for their purchasing decisions.

4. The Ordering or Viewing Appointment. Too many photographers avoid having clients return for an ordering appointment, saying they don't like to sell or are not good at it. They take the easy route of uploading the images to a web site for the client to purchase at home in their own time. This is the surest way of killing your sales and costing you money.

There are several reasons why providing only online ordering is a very bad idea, especially if you want to build a boutique business. First, you have to edit or retouch all the images you post— and working on more images than your client

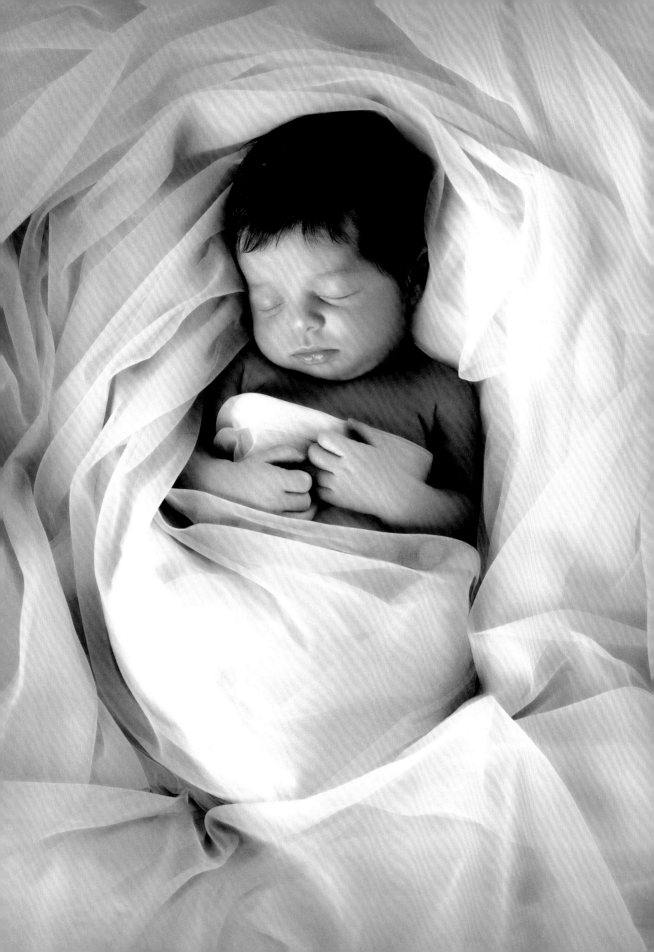

will buy costs you time and money. Second, you can't generate excitement when your artwork is displayed so small. Bigger is better! Because the client cannot see the detail of the tiny images, you'll get more requests for cropping and other adjustments. This back-and-forth with the client by e-mail is far too time-consuming for it to be profitable and it delays the ordering process. Third, allowing for an extended time to order only lowers the size of the order. Life gets ahead of us all and, eventually, ordering images becomes just another chore to do. The more time elapses, the higher the likelihood your sale will dwindle. Finally, you cannot provide expert advice on the best finishing options. It's extremely hard to sell framed images when the portraits are viewed online only. Clients need to touch and feel your frame samples to make an accurate decision. Similarly, you cannot make on-the-spot changes or design custom collages if your client is not sitting in front of you to convey their opinions.

Projecting the images in a slide show set to music is the best way to generate the excitement. Just think about how we are prepared to pay more to watch a movie at the cinema than later on DVD. We love the comfy chairs, the surround sound, the clear and crisp visuals, the smell of popcorn, etc. Making it a real experience for the client sets the tone for optimal viewing pleasure. The more engaged your client is, the more open they will be to investing with you. In fact, photography is one of the only businesses in which tears are good! The emotionally involved client will feel connected to the wonderful images they are seeing—especially when these are coupled with emotive music. Make sure to keep a box of tissues on hand, and offer a tray of chocolates to keep the good vibrations going.

It's advisable to schedule the ordering or purchasing appointment no longer than two weeks from the date of the session (seven to ten days is the magic number). As time passes, excitement wanes—and you want to keep the client excited to see their image collection. Again, remind your client of the appointment the day before to avoid wasting time on no-shows. Even though this is technically an appointment for the client to *view* their images, it is also when they will place their order. As such, calling it the *ordering* appointment mentally prepares them to expect to invest their money.

The first time they see their collection, play it as a slide show in which each image is displayed individually. Avoid distractions or talking during this initial slide show. Allow them to get engrossed in the emotion of the moment. I find that choosing music with lyrics related to the images (like "My Baby Boy") works better than selecting instrumental tracks; a voice singing words seems to prevent the clients from talking among themselves and getting distracted.

After the first run-through, review the images one at a time and offer them three options: they can either choose to keep it as a favorite, they can put it in the "maybe" category if they're un-

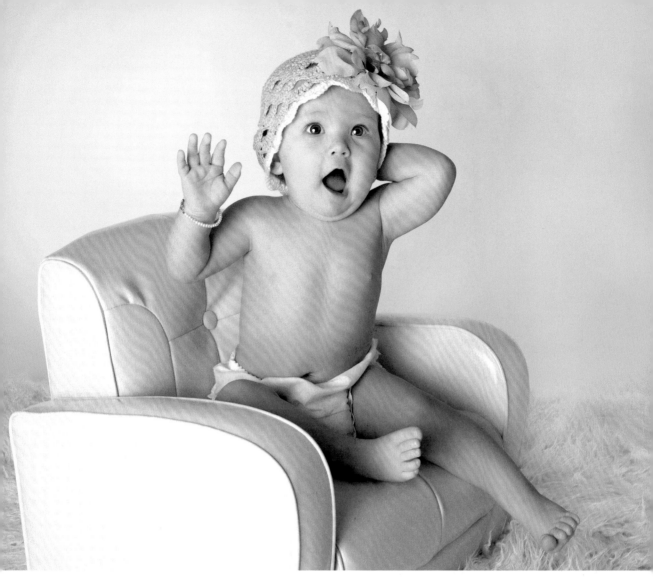

Projecting images in a slide show set to music is the best way to generate excitement.

sure, or they can have you discard any images they don't like. This immediately reduces their image picks to their absolute favorites, helping to focus their purchasing decisions.

Telling your client that you only keep the images they order encourages them to place their order on the spot. Adding a little bit of pressure is not a bad thing; you certainly don't want them to think they can go home to make their ordering decision later. This will be disastrous to your bottom line and your workflow schedule (remember, time is money). Most clients will feel like they don't want to lose any of their precious memories, so you can offer products like proof books that allow them to keep the entire collection—but only once a minimum order level is reached. After all, you don't want them *just* ordering proof books. Narrowing down

their selection helps to avoid your having to store images they will never order—images that take up much-needed storage space.

At this point, take down all the order details. Or, better yet, use software like ProSelect to input all the variations of sizes and products you offer, streamlining the ordering process. Being able to automatically print out the order with order totals and thumbnail images helps ensure the order is taken accurately.

At this point, you can offer credit card facilities or installment payments to make the investment easier for your client and provide you with a monthly cash flow you can count on. Explain

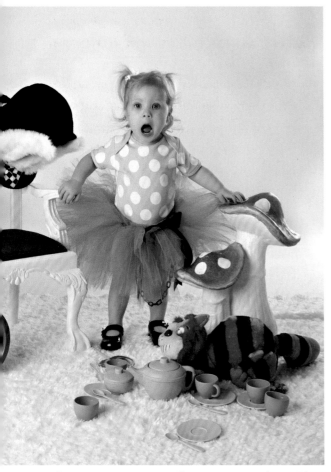

It's important to continually impress your client with simple gestures of thanks and appreciation.

your turnaround time, noting that quality takes time, so they know when they can expect their order to be ready.

As soon as your client leaves your studio, make out a hand-written thank-you note for their order and pop it in the mail. It's important to continually impress your client with simple gestures of thanks and appreciation. Personalizing communication goes a long way toward impressing them and showing you value their investment.

We use a fabulous service called Send Out Cards. Using this online greeting-card service, you can personalize a card with just a few mouse clicks—and without having to leave your chair. It provides a huge selection of pre-designed templates and card designs you can pick from—better yet, you can upload your own graphics and photos to create a custom design. In addition, printing and mailing the cards is far cheaper than if you bought a card and stuck a stamp on it yourself. If you want to totally knock the socks off your client, you can send them a personalized card along with a tangible gift! We love to include a $5 Starbucks gift card with our thank-you cards so they can enjoy a gift on us while anxiously waiting to see their heirloom artwork. It works like a charm!

Check it out (and claim a free card on me!) by visiting www.sendoutcards.com/mimikacooney. If you're interested in the earning potential side of Send Out Cards, you can sign up to become a wholesaler and refer people to use the service. Then you'll start earning a commission yourself.

5. The Pick-Up Appointment. Making a separate appointment for your client to collect their order is another important step in generating enthusiasm. Even though it means more time for you and your client, it is much more personal

Pretty bags and bows make the purchase feel even more special.

The way that you package your portraits makes a big difference.

than just sticking their prints in the mail. They will be excited to see how their portraits have turned out, so you want to make their first viewing as much of an experience as when the images were taken.

Knowing when your client will be coming also allows you to prepare the area for maximum impact. Consider putting their art piece on an easel under an overhead light so that when they step into the room they are immediately taken by the sight of their own imagery. Telling them how wonderful you think it has turned out also gives them a sense of ease that you are confident and avoids the dreaded buyer's remorse. Also, take the time to explain how they can best care for their artwork (use a dry cloth to dust, avoid hanging it in direct sunlight, etc.).

The way that you package your portraits also makes a big difference. Remember to use pretty bows and bags for that boutique touch. Adding extra gifts that they weren't expecting (wallet prints, play date cards, chocolates, bag tags, etc.) will generate more love for your brand.

The final step in ensuring they spread the love for you and your business is to actually ask them to tell their friends about you. I know this can sometimes be embarrassing, or you may feel shy about asking—but it won't happen by itself. Ultimately, a boutique business should go the extra mile to make their clients feel so special and appreciated that they can't stop talking about all the wonderful things you do.

A PRODUCTION CHECKLIST

For continued success, it's imperative that your clients' experiences are consistent. Following a structured workflow system allows you to keep your standards high and avoid costly mistakes. Having "to do" lists will help; just note each step that is required before going on to the next. This is particularly important when you have more than one person handling a client's order and need to keep everyone in the loop about what has been done already and what should be done next.

For each order, a production checklist should tell you exactly what stage you're at: retouching, printing, assembly, delivery, etc. An additional retouching checklist should also be used, outlining

each step that needs to be taken in order to keep the color and style consistent: white balance check, levels adjustment, contrast refinement, skin smoothing, blemish removal, added textures and text, etc.

Client Name		
Session Date	**Ordering Date**	
Delivery Date (4 weeks)		
Email		
Task	Date Completed	By
Raw Images saved from card & backed up		
Proof images selected, color corrected		
Proofs exported to view folder		
Online event created & emails added		
Ordering Prep		
Proof images prepared for viewing		
Ordering appointment conducted		
Thank you for your order card sent		
Payment made/ Credit card charged		
Retouching		
Retouch: JPG Images exported to folder		
Retouch: Skin softening action		
Retouch: Remove blemishes/red marks/lint		
Retouch: Images cropped & sharpened		
Retouch: Images effects added, renamed		
Retouch: Finished images uploaded		
Copy finished files to hard drive		
Order Production		
Prints ordered		
Frame ordered		
Canvas ordered		
Gallery Block ordered		
Album ordered		
Proofbook ordered		
Rep cards/ Playdate cards ordered		
Announcement/Holiday cards ordered		
Branded gift ordered/ spiral notebook		
Online Marketing		
Facebook upload		
Pictage upload		
Added to blog		
Email link to blog – share with friends		
Order Production Receipts		
Order status update sent		
Frame arrived		
Prints arrived		
Proofbook arrived		
Order assembled		
Contacted for pick up		
Order picked up		
Order shipped to client		
Post Production		
Backup DVD of finished files, copy to harddrive		
Follow up call made		
Feedback survey emailed		
Re–order/Re–do ordered		
NOTES		

For each order, a production checklist should tell you exactly what stage you're at. This is how I've designed my own checklist.

7. MATERNITY PORTRAITS

"A baby is God's opinion that the world should go on."—*Carl Sandburg*

A self-portrait of the author seven months pregnant.

Being pregnant is like having an alien live inside of you. Your figure morphs into something unrecognizable, your feet swell, your skin breaks out, your eyesight gets worse, your back aches, you're tired all the time, you constantly need to go to the bathroom, you're nauseated, you can't eat some of your favorite foods, you're sensitive, and you're an emotional wreck!

Looking good while you're pregnant is hard—especially when you don't feel good. (This is not to say there aren't moms-to-be who sail through their pregnancy blissfully happy, but they're the exception rather than the rule.) To provide a service where you can make a mama look and feel good is a wonderful thing indeed! Handling your pregnant client requires kindness, patience, consideration, empathy and a little TLC. Encourage Mom to share her excitement about her baby bump, to talk about her nursery ideas, and describe the things she loves. Creating a calm atmosphere will help settle her nerves and pave the way for a relaxed, enjoyable experience. We do this by providing ample guidance and direction.

THE IDEAL TIME

The ideal time to capture the pregnant glow is when Mom is between weeks twenty-eight and thirty-five of her pregnancy. During these weeks, the beautiful baby bump has a perfect shape, the mom-to-be has more energy, and there is no fear of imminent labor. It is advisable to schedule the maternity session earlier rather than later—before the mom starts to feel heavy and too exhausted to be enthusiastic about it.

Many moms will be worried about stretch marks and blemishes; put their minds at ease by advising them that you provide full retouching to give their skin that delicate glow and make them look their best. Encouraging other family members to join in the session can make it more personal and allow you to capture a more

RIGHT—Tickling bellies can produce great expressions.

BELOW—Serious expressions capture more emotive memories.

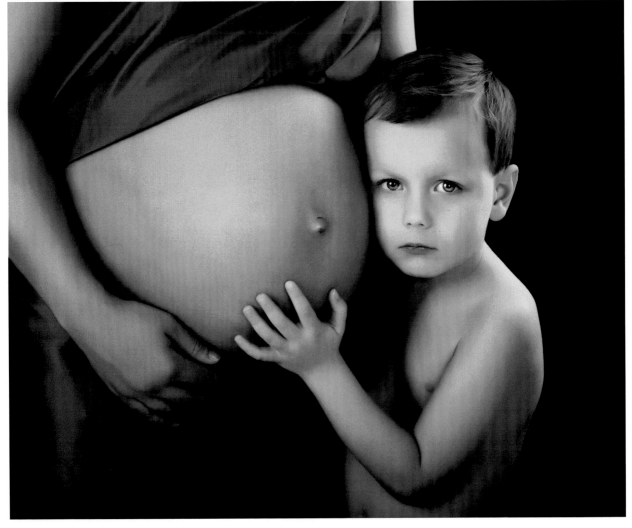

complete story of their family. It also helps Mom to relax—especially when Dad is there to offer support. Older children can also be included for those intimate close-ups of big brother or sister hugging Mom's belly.

CLOTHING OPTIONS

One of the most common questions I am asked by clients preparing for a photo session is what clothing to wear. I always advise them to keep their clothing choices simple and solid. It's best to avoid distracting patterns, dots, stripes, and branding; these will date the photo in years to come. For maternity portraits, black and white tank tops are a great staple for a neutral look, as are a comfortable pair of jeans. Dad can also wear a plain, solid-colored shirt and jeans for a classic look.

Mom should bring clothing that is tight-fitting rather than oversized, so that the clothing helps to show off her baby bump rather than hide it. Very often, I still need to clip the clothing to fit more snuggly so that the shape of the belly is better defined. Shirts with three-quarter length sleeve are more flattering than sleeveless tops, as moms-to-be invariably carry a little extra weight that shows on the upper arms. Avoid the "chicken fillet" look by covering the upper arms with sleeves.

You can bring a little personality into the session by asking Mom to bring clothing that represents her personality: cowboy boots, designer heels, baseball caps, etc. It's better to have more clothing to choose from than to have too little, so encourage Mom to bring plenty of options for you to pick through. Jewelry, however, should be kept to a minimum; it can draw attention away from the focus of the portrait—her baby bump.

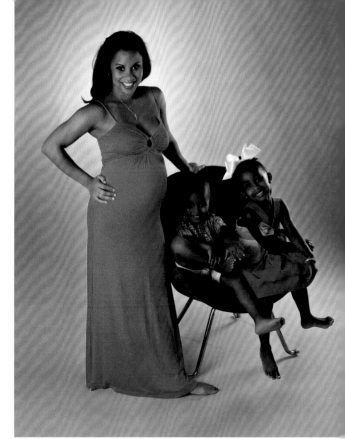

Having everyone's clothing match in tone and style gives the portrait a classic look.

HAIR, NAILS, AND MAKEUP

A little bit of preening goes a long way toward giving a portrait that finished look. If Mom has the time to arrange it, a trip to the salon just before her portrait session is a good idea. If this is not feasible, you can offer her some great advice on how to prepare herself for the session.

Advise Mom to arrive with cleanly washed hair, preferably with a little mousse or gel applied to tame those flyaway hairs (believe me, they're a pain in the neck to retouch later). Remember that you'll be doing close-ups of both Mom and Dad's hands, so make sure their nails are clean and gently manicured (just a clear varnish will do). It's also advisable to moisturize before the session so that the hands, belly, and arms have a smooth complexion.

EASY STEPS FOR FLAWLESS MAKEUP

Step 1. Clean the face, pat it dry, and tone. Then, apply a light moisturizer to the entire face, including the eyelids.

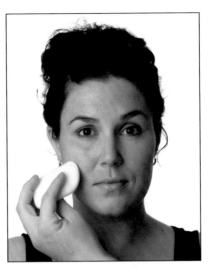

Step 2. Test the foundation shade by applying it to a small area along the jaw line. It should be neither too light nor too dark; you don't want to see a difference between the face and the neckline. If necessary, blend shades to get the correct tone.

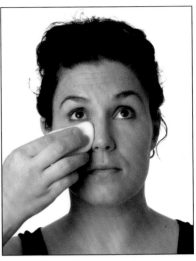

Step 3. Apply the foundation with a sponge using upward strokes. Blend it into the jaw line and hairline.

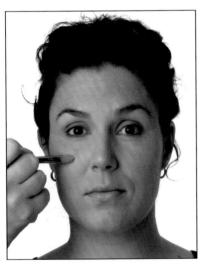

Step 4. Apply concealer to any dark spots and blemishes. Many pregnant moms experience the "mask" of pregnancy, which causes dark pigmentation on the face. Applying a plain concealer or a heavier camouflage can hide this. Use a fine brush (in a stroke and stipple or dabbing motion) to even it out with the surrounding skin. Apply concealer to the eyelids to prime them for eye shadow.

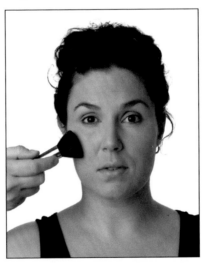

Step 5. Apply a mineral-base pressed powder. This gives the skin a matte look, which is preferable for photos, as any reflection on the skin creates issues later. With a large, soft brush, apply the powder using a circular motion.

Step 6. Contour the eyelids with three tones of eyeshadow. Using a soft, thin brush, start the lightest shade at the upper brow along the brow bone.

Thanks to Alynne DeHart Davis for providing the makeup application and tips, and to the model, Tiffany Russell.

Step 7. Next, using a medium shade, work in under the eyebrow line along the eyelid.

Step 8. Proceed blending the darker tone onto the crease of the lid. The finished eyes should look shaped and really stand out. Use concealer to clean up any loose eye shadow that may have fallen under the eye.

Step 9. Apply eyeliner. For a more natural look, place the eyeliner only along the lash line on the top lid, not to the lower lid.

Step 10. If you are after a more dramatic look, you can include the lower lid. Using a cream based dark shade (brown or black) with a very small brush gives you more control than using a pencil or liquid eyeliner.

Step 11. Apply mascara using a twirling motion, rolling the brush in between your fingers. Work your way into the corners of the eyes, too. Check that both eyes look even.

Step 12. Apply blusher or bronzer for chiseled cheekbones. Having your model squeeze her lips together (into a fish face) will help to reveal the cheek line. Brush the blusher in an upward motion toward the temples.

Step 13. Using a lip-color pencil that is a shade darker than the natural lip color, carefully outline the lips. Avoid using a color that is too dark; the liner should enhance the shape, not make the model look like a clown!

Step 14. Fill in the rest of the lips with the pencil to blend in the edges. Then, apply a clear gloss directly over the filled-in lip liner as a final touch— or add lipstick in the same shade as the lip liner to finish off the look.

The finished look. (*Note:* For blonds, you may need one more step: brushing in the eyebrows with a neutral brown to define them.)

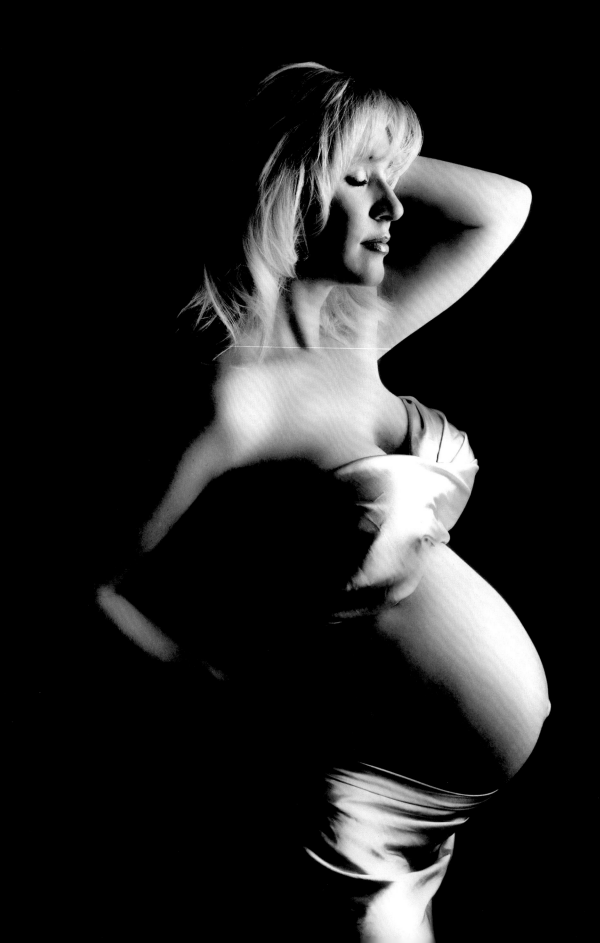

Applying makeup makes a huge difference in the look of the final portraits and greatly minimizes the need for retouching. Suggest applying her makeup a little heavier than usual; this helps compensate for the photographic lights, which tend to wash out the complexion. The subject should apply a color-matching foundation (not too heavy, though) with bronzer or blusher on the cheek bones. Adding darker-than-usual mascara and eyeliner will make their eyes stand out. Lip gloss or natural-colored lipstick looks far better than bright reds or heavier tones and helps to outline the lips.

FLATTERING POSING

Now that you have the client dressed, styled, and in position in the shooting area, explain the most effective way to stand for ideal posing. Pregnant moms need to push their weight toward the hip that is away from the camera so that they don't get dizzy. A pregnant woman's blood pressure can drop dramatically if she stands for too long in the same position, so have her sway from side to side in between pose adjustments to keep the blood flowing. Offer sips of water, a break to take a seat, and sucking sweets if she gets dizzy. Use a fan to keep cool air on her; during pregnancy, the body temperature is elevated, so she really will feel the heat.

I suggest starting with a flattering, basic pose that works for any maternity session. Just have her turn her hips to a 45 degree angle from the camera so the shape of her belly is more visible. Her front foot should be pointing toward the camera and her weight pushed out away from the camera toward her back hip. A bend in the knees will tilt her pelvis forward and create a comfortable "sitting" position for better stability. Never

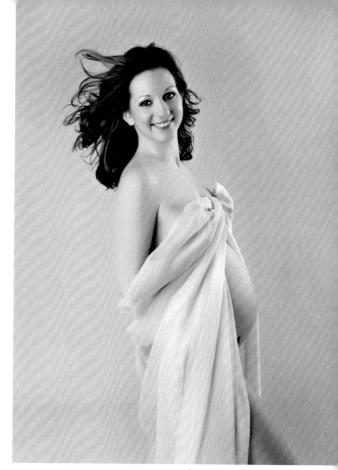

FACING PAGE—Makeup minimizes the need for retouching.

ABOVE—Pose the mom with her hips at a 45 degree angle to the camera with her weight on her back foot.

let her stand with her knees locked or she will fall forward.

Another great pose for showing off the shape and size of the belly is a complete profile shot, where Mom faces the side at a 90 degree angle to the camera. Again, have her follow the rules of shifting her weight toward her back hip and tilting her pelvis forward. Turn her head into the light and have her lift her chin slightly to avoid the chicken-neck look. I also love this pose for couples; I have the mom and dad stand close together and close their eyes in a look of nostalgia. (Just remind Mom to open her eyes immediately after the shot is taken to avoid her falling over.)

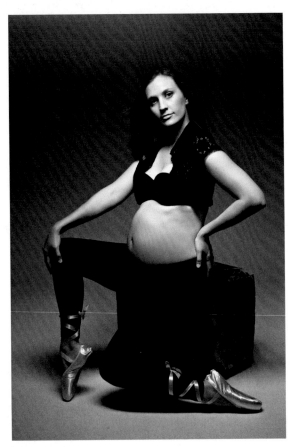

ABOVE—Pose the hands softly, like a ballerina.

FACING PAGE—A profile pose shows off the shape of the belly.

Posing the hands correctly is important for creating a sense of flow in the portraits. Make sure that the backs of the hands are not facing the camera, as they tend to reflect a lot of light and can appear exaggerated in size. Avoid "spider fingers," where all fingers are spread apart. Instead, keep the fingers looking natural by adding a slight bend. Think of softly bent wrists like a pianist and poised fingers like a ballerina.

STUDIO LIGHTING TECHNIQUES FOR THE PREGNANT MOM

We use light to accentuate features and shadow to hide them. The larger the light source, the more of the subject will be illuminated; the smaller the light source, the less of the subject will be illuminated. With a pregnant mom, the worst thing we can do is slap on a big, flat lighting source that makes her look fat and frumpy. The following are some simple pointers for lighting strategies that will be much more flattering.

Zorro Lighting. The setup and light placement that I have in my own studio is something I like to call "Zorro" lighting. It's a name inspired by the movie *The Mask of Zorro*, where the masked character carves a "Z" with his sword as mark of victory—his calling card. I'm a visual person, so remembering to place the lights at the intersecting points of the letter "Z" helps me make sure each light is set properly. Because my studio is only 10x12 feet (it was intended to be my home's dining room), I use track lighting on the ceiling to maximize my floor space and to avoid having busy toddlers knock over light stands.

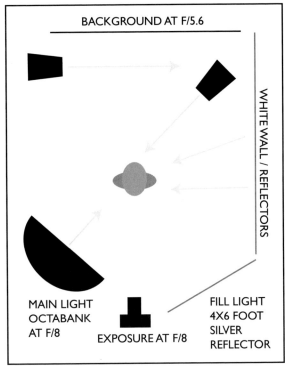

BACKGROUND AT F/5.6

WHITE WALL / REFLECTORS

MAIN LIGHT OCTABANK AT F/8

EXPOSURE AT F/8

FILL LIGHT 4X6 FOOT SILVER REFLECTOR

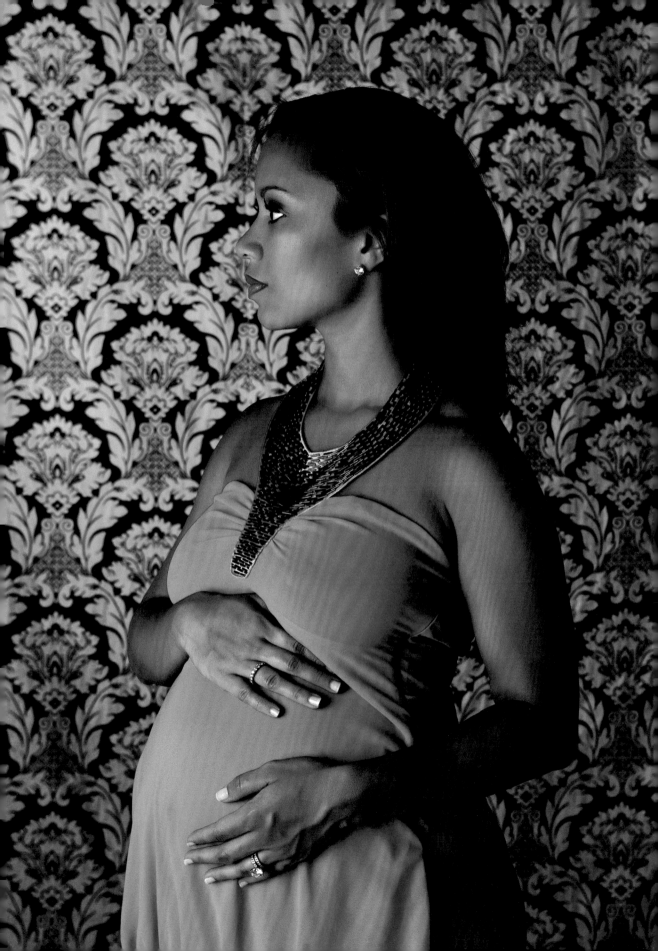

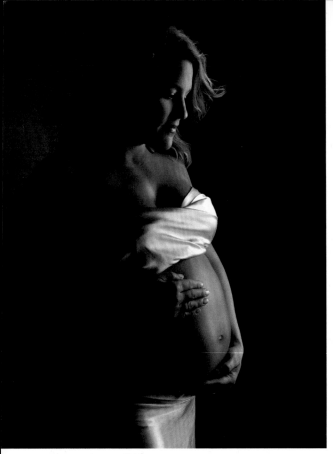

For Rembrandt lighting, the main light is set at a 45 degree angle.

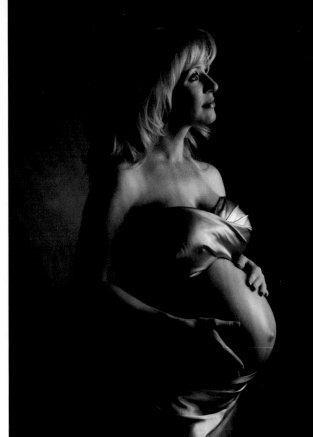

Illuminate the background to create separation.

Snap, Crackle, Pop Lighting. I like to remind myself of three simple words when shooting in the studio: snap, crackle, and pop. These easy reminders help create a portrait with depth and dimension.

Snap. To create snap in a portrait you need to have a main light source that is soft and flattering and you need to position it properly. I love my Elinchrom Hexagon and strip softboxes for the purity of their light. I prefer to place my main light at a 45 degree angle to the subject's nose and elevate it just above the subject's eyes. Placing the main light at an angle ensures the shape of the face is sculpted by a shadow on the side of the nose. In photography circles, we call this Rembrandt lighting, named for the Dutch painter.

Crackle. Add some depth to your portraits by creating separation between the subject and the background. This can easily be achieved by adding a background light to the mix. You can place the background light either perpendicular to your background or point it at an angle toward the background for a spotlight effect. Just remember to keep your subject at least three feet away from the background to avoid any spill falling onto their hair or face. For even more separation, add an additional hair light at 45 degrees behind your subject's shoulder pointing toward the main light.

Pop. The pop in a portrait involves the eyes. They are the most important part of the subject's face and must be clear and bright in the portraits. To add the "pop" on the eyes, you can use an ad-

ditional light. I prefer, however, the specular highlights created using a reflector. Placing a very large reflector (mine is a 42x72 inch free-standing silver reflector by Larson Enterprises) at a 45 degree angle to the subject's nose, on the opposite side from your main light, will do the trick.

Profile Lighting. With profile lighting, you use one or maybe two lights to produce a more dramatic mood. Considered subtractive lighting, you are hiding areas of the subject in shadow and

Use a reflector to add "pop" to the eyes.

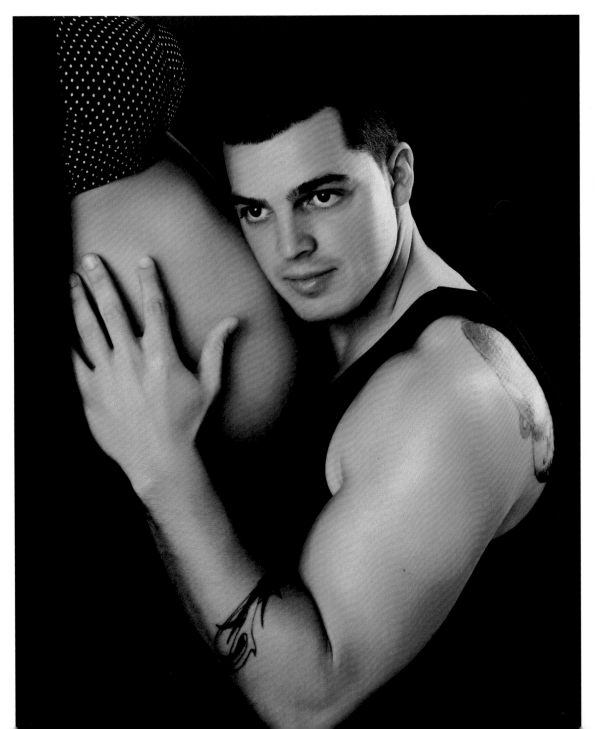

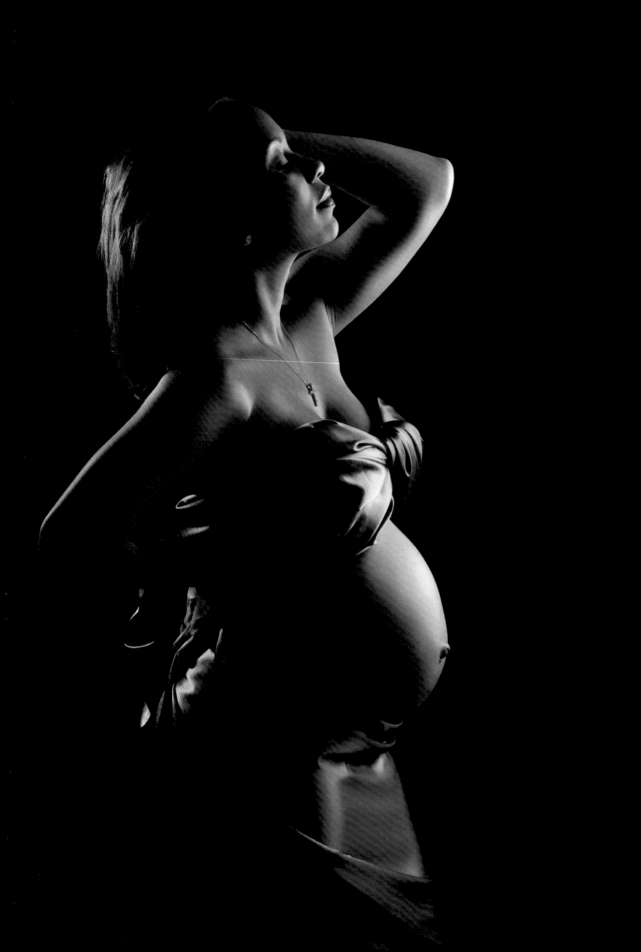

highlighting only those areas you want to be prominent; in this case, that's the pregnant belly. This approach works well when you don't want to show the subject's chubby arms or back rolls—and believe me, moms appreciate this!

This type of lighting also works well for a portrait of Mom and Dad both facing the light source so that you see their profiles and their hands on the belly. We use the same basic configuration as in the Zorro setup, except we remove the large softbox and make a stripbox the main light. The background light remains the same, as does the reflector. You can turn the background light with barn doors toward the subjects' backs as an accent light.

These are some staple lighting setups that will always put you in good stead. There are many more lighting variations you can try. The best book I've read about lighting styles is *Master Lighting Guide for Portrait Photographers* by Christopher Grey (also from Amherst Media).

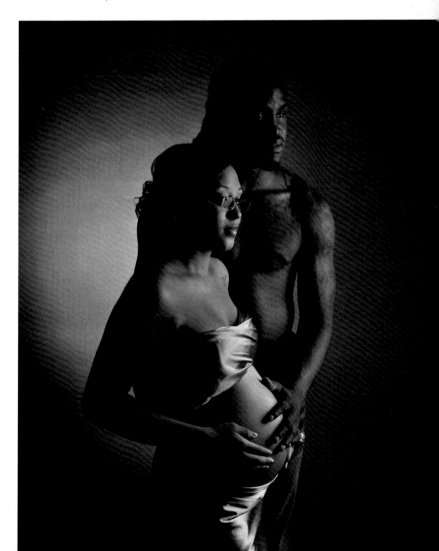

FACING PAGE—For profile lighting, the main light placed to camera right.

RIGHT—A stripbox was used for side lighting.

8. NEWBORN PORTRAITS

"A baby will make love stronger, days shorter, nights longer, bankroll smaller, home happier, clothes shabbier, the past forgotten, and the future worth living for." —*Anonymous*

The emotion a parent feels when they see their baby's smile has a visceral effect on them. There is something about seeing your baby smile for the first time that warms your heart and uplifts your soul!

IN-HOSPITAL BIRTH SERVICE

The moment a baby takes his or her first breath is the first time a portrait should be taken. For my in-hospital birth service, I provide a collection of images of the baby's birth. Some moms request that the entire birthing and delivery process be photographed, but more often I am asked to document the first few hours of the baby's life, while Mom and baby are still in the hospital. For these photos, the job of the photographer is to capture the fleeting moments like a documentary, allowing the new parents to focus completely on their new arrival without worrying about missing any of their precious memories. You're recording all the excitement, the emotion, the happy tears and joyful laughter, the milestones of cutting the cord, the printing of baby's first tiny footprints, Grandma and Grandpa's very first glimpse of their grandchild—all the things Mom usually misses during her recovery following the delivery.

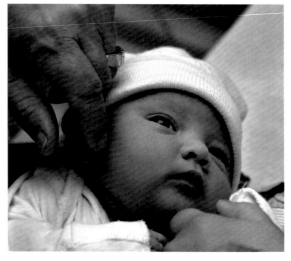

Grandpa's first glimpse of the new baby.

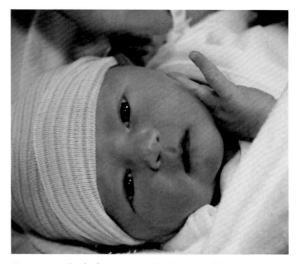

Capturing the baby at just 45 minutes old.

Baby's very first portrait—at just a few hours old.

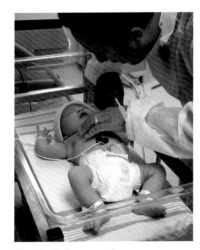

Hospital photography captures the moments Mom will miss while recovering.

You can capture special images in the moments when the baby meets the family for the first time.

I've been offering an in-hospital birth service for years, and I get asked by many photographers how to approach this. Obviously, births are unpredictable by nature, which makes planning almost impossible. Therefore, I work closely with the parents and keep my cell phone close by for a last-minute rush to the hospital. It's entirely up to you to decide on your availability and the number of these types of bookings you're prepared to commit to. Offering availability between 7AM and 7PM is reasonable, considering you

ABOVE AND FACING PAGE—
Capturing the baby's first twenty-four hours.

It's imperative to plan ahead and have the parents both sign a contract of service.

probably have your own family to take care of. You're not required to rush to the hospital or birth center at 4AM—unless the parents specifically request it and are willing to pay for your time. I advise my clients to call me as soon as baby has arrived rather than when Mom goes into labor. Otherwise, you could end up waiting for hours! I commit to taking the photos within baby's first twenty-four hours, giving me a window of time to plan around.

My other commitment is to produce an online birth announcement within twenty-four hours of taking the photos. This is a slide show set to music and featuring baby's first portraits along with their birth stats (weight, height, and length, plus date and time of birth). My service also includes distributing the slide show announcement by e-mail to the client's list of friends and family so that they receive news of the arrival within forty-eight hours of the birth—and usually while Mom is still recuperating in the hospital.

It's imperative to plan ahead and have the parents both sign a contract of service. They should also sign and complete a model release to cover displaying the image collection online. Make sure your clients also notify their health-care providers so that you can

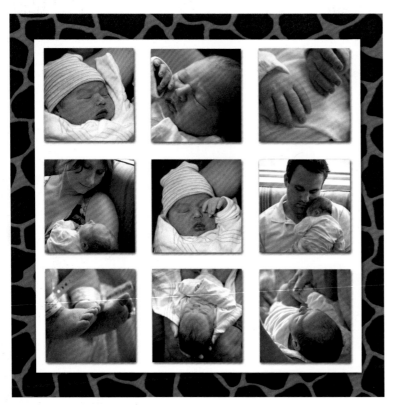

An album collection of baby's first hours.

be added to their list of approved guests. Some hospitals are quite strict about who may or may not visit the new family, especially within the first few hours of recovery, so cover this point up front.

Pricing this service is based on time, so determine what your hourly rate is and apply that to the number of hours you expect to spend. Consider these factors when creating your service:

1. Travel time to and from the hospital/home/birth center.
2. Photography time capturing the photos (three hours is usually sufficient).
3. Editing and retouching time.
4. Time spent on the slide show compilation.
5. Cost of the music rights to use royalty-free music.
6. Cost of hosting the slide show.
7. Cost of hosting the image collection online.

TIPS FOR PHOTOGRAPHING BABIES

Clothing Choices. Babies are best photographed in their birthday suits—just plain naked. Most clothing swallows up a newborn and

Some hospitals are quite strict about who may or may not visit the new family . . .

FACING PAGE—Newborns are best photographed naked.

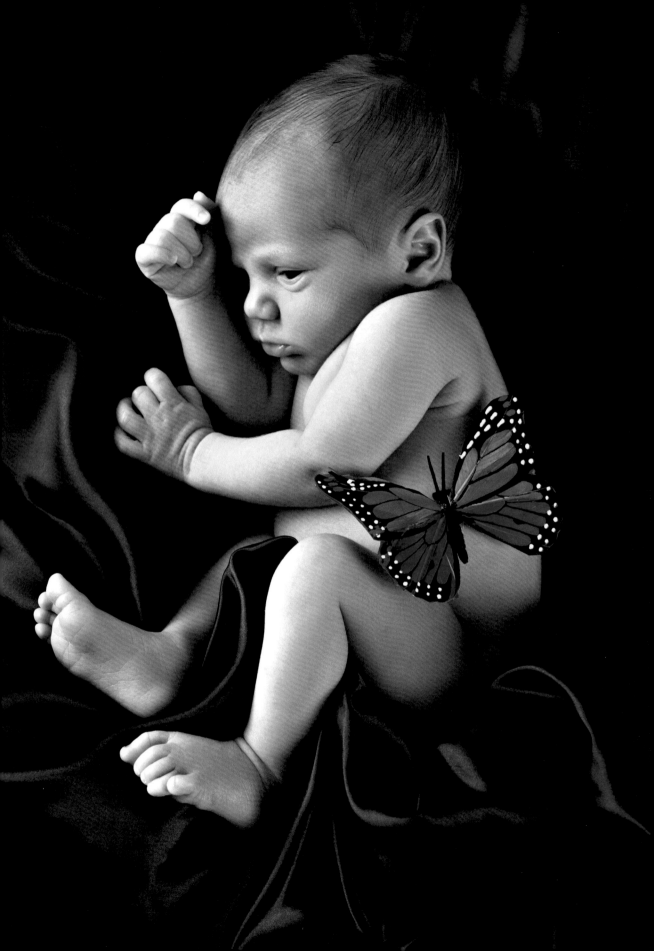

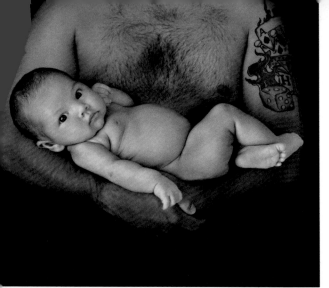

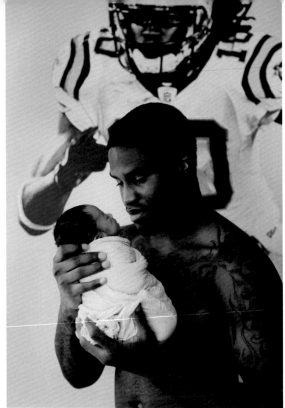

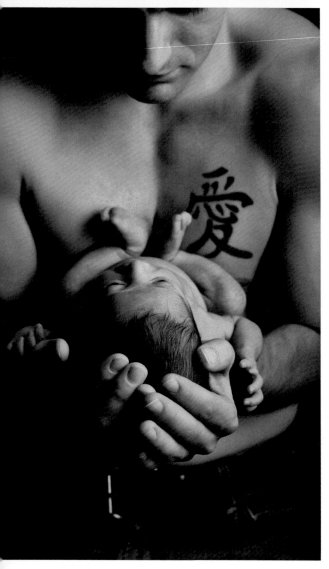

disguises what's so cute about their tiny shape. The parents' own clothing choices should be simple and neutral. You want to highlight their relationship and special bond with their new baby, not their outfits. Plain black long-sleeved shirts with jeans work very well.

Moms just love seeing Daddy shirtless holding his little baby bundle—and there really is something special and heartwarming about seeing a dad's strength in contrast with the delicateness of a newborn baby. So off with the shirts, Dads! Even if the father is not completely comfortable with his shape, you can use lighting to artistically hide the areas he doesn't want highlighted (usually the arms and tummy).

THIS PAGE AND FACING PAGE—Moms love shirtless dads—and portraits like these let you tell a story by contrasting the delicate with the strong. Using dramatic lighting you can artistically hide any areas that Dad isn't comfortable having seen.

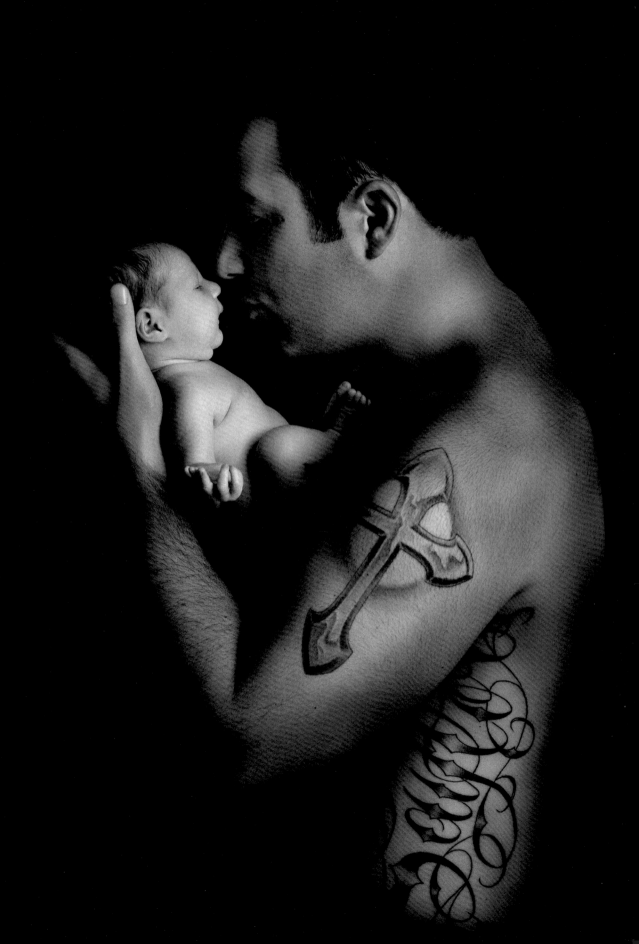

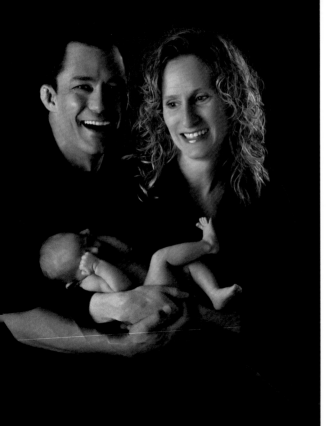

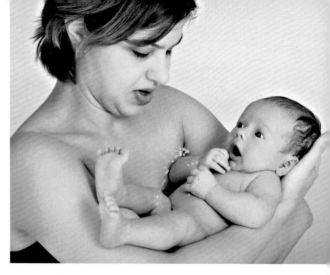

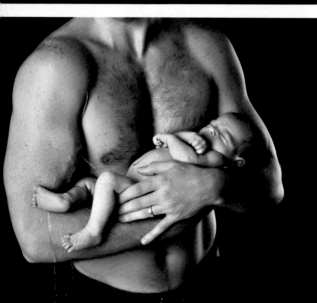

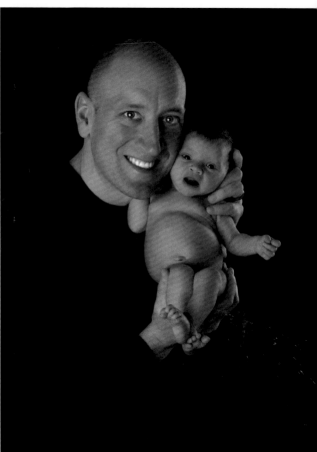

Accidents Will Happen! With most newborns, we're tempting fate with those cute curled-up naked baby portraits. I always tell parents, "It's not *if* but *when*." Don't panic; just be prepared for pee and poo accidents, keeping clean-up supplies at the ready. In my studio, we have an easily wipeable floor, loads of antibacterial

With babies, accidents are a matter of when, not if.

wipes, paper towels, and hand sanitizer. Very often, the baby will warn you that they need to go by crying and wriggling. If they do, place a clean diaper loosely under their buttocks until they settle. It's also advisable for the adults to bring an extra set of clothing; the probability is very high that someone is going to get wet!

What to Do When Baby Cries. Sometimes even adults wake up on the wrong side of the bed, so it is completely understandable that a child might cry during a photo session. If that happens, it's best to pause the photography and give the little one a hug and cuddle to make them feel secure. The bright flashing lights, strange noises, and unfamiliarity can cause uncertainty. Crying may also be a sign that the child has passed their patience threshold. In that case, there is no use in forcing the matter; just wrap up the session quickly. They may even be unwell or coming down with a cold. If that is the case, reschedule the session for when they are feeling better. However, if it really is just a case of nerves, then a really talented photographer should be able to offer distractions to

> The bright flashing lights, strange noises, and unfamiliarity can cause uncertainty.

Naked newborns *will* cry.

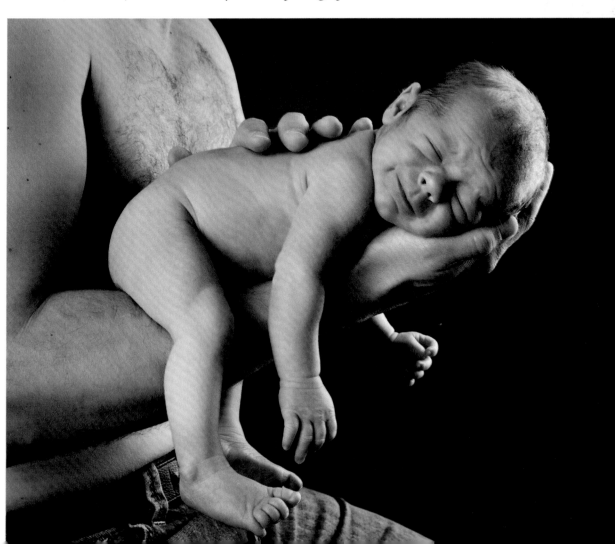

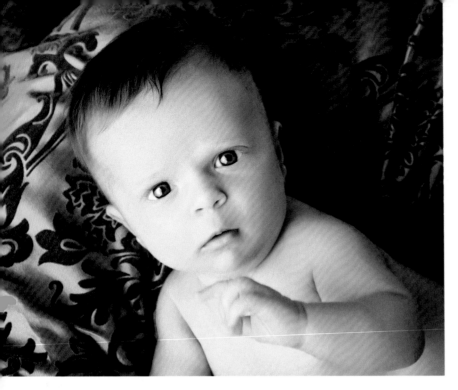

A properly executed portrait must show catchlights in the eyes.

both the mom and the child and re-focus them when they feel at ease again.

Usually, persistent crying is baby's sign that they are tired or about to fill up their diaper. If you can bear through the howling, swaddle them and rock them until they nod off. A great tip I got from the baby-whisperer Tracy Hogg is to use techniques in threes. For example, pat the baby's back while "shooshing" loudly enough that the baby can hear it over their own crying, also while rocking. I like to use a sound machine that mimics womb sounds to offer that familiar heart-pumping the baby got used to in Mom's tummy. Remember that, just days ago, the baby was tightly curled up in the womb, so all the flailing about they now find themselves able to do makes them feel insecure.

Always have an assuring hand on the baby's back or head to offer that feeling of warmth and security. Also, have Mom feed the baby in between poses; a full belly helps them sleep. Another great tip is to place a heating pad, gently warmed in the microwave, under a blanket and lay the baby on their side or tummy.

Keep the Lighting Simple. Using a simple lighting setup helps to produce consistent results without you making many adjustments during the session. This is important, because timing is crucial. The main light source should be large and soft. It needs to be forgiving on the skin tones and to hide the apparent tiredness the new parents will be feeling. I love my Elinchrom Hexagon softbox for this purpose and the catchlights it produces in the eyes are gorgeous. Refer back to chapter 7 for the Zorro lighting setup.

Posing for Relationship Imagery. To make an image collection more saleable, keep a mental note of the poses taken so that you get every possible combination. When you get a close-up of Mom holding the baby in a cheek-to-cheek position, remember to do the same with Dad holding the baby. During the ordering appointment, having shots that match will make it easier to assemble a lovely wall collage or image collection.

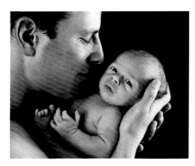
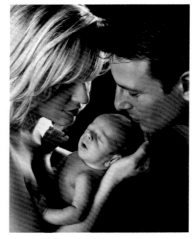
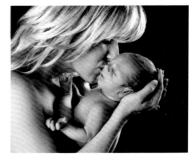

Strive to capture matching poses. These lend themselves well to wall collages and image collections.

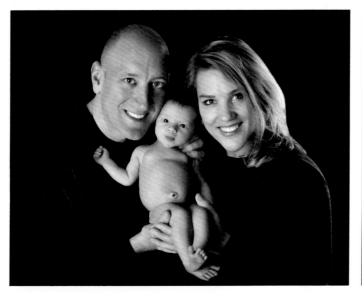
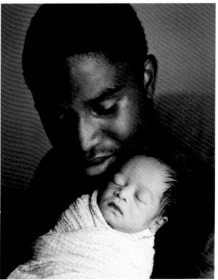

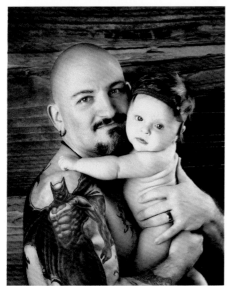
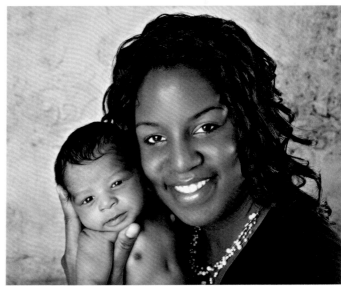

Some other ideas for poses that work well together as relationship imagery.

BABY'S FIRST YEAR: THE MILESTONE BUNDLE

It's more difficult to get a new customer than to keep an existing customer happy, so why not give your clients every reason to come back? Babies grow exponentially in their first year and every stage is fleeting, so it's important to create keep-

My studio's Baby Milestone Bundle.

sake images regularly and frequently. However, for parents with a new baby, even the simplest tasks become difficult—so providing a service where *you* do the organization for them is something that will be greatly valued.

In my studio we offer a "Baby Milestone Bundle," which covers baby's first year with photographs every three months for a total of five sessions (newborn, three months, six months, nine months, and one year). When we started this program, we offered just three sessions (zero to three months, six months, and twelve months). But I soon discovered that parents were taking their baby somewhere else to capture the intervening changes. I decided I didn't want to share my clients with other photographers, so I started offering the extra two sessions for free. It's proven to be very successful—and although I don't charge for the extra sessions, the order value per session is more than I expected. By doing these sessions, I eliminate the risk of having the competition steal my clients away—and it provides more regular income.

It's best to have the family commit to the bundle while they are still pregnant so that you can coordinate session dates within the relevant

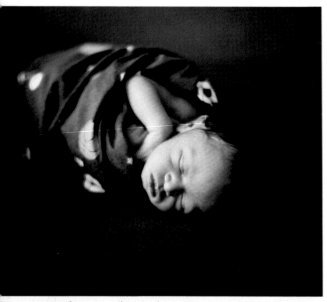

Newborns are heavy sleepers.

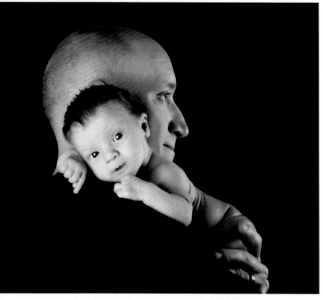

Many babies are born alert and give us the opportunity to capture their eyes open.

timetables. This is crucial when it comes to the newborn session; setting a photography date for when the baby is seven to ten days old takes some advance planning.

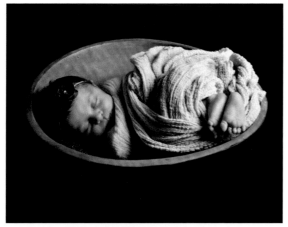

The Newborn Session. As noted, the newborn session should be conducted when the baby is seven to ten days old—when the infant is still a heavy sleeper and curled up in a fetal position. By the time they are three or four weeks old, babies starts to stretch out their legs and lose that sweet curled-up look. Also, by about three weeks of age, roughly 20 percent of newborns develop baby acne. This makes retouching and finishing the images very time-consuming.

This will be the longest of the first-year sessions, lasting two to four hours. A newborn baby cannot be rushed and will need breaks to be fed

Using props adds to the character of the portrait.

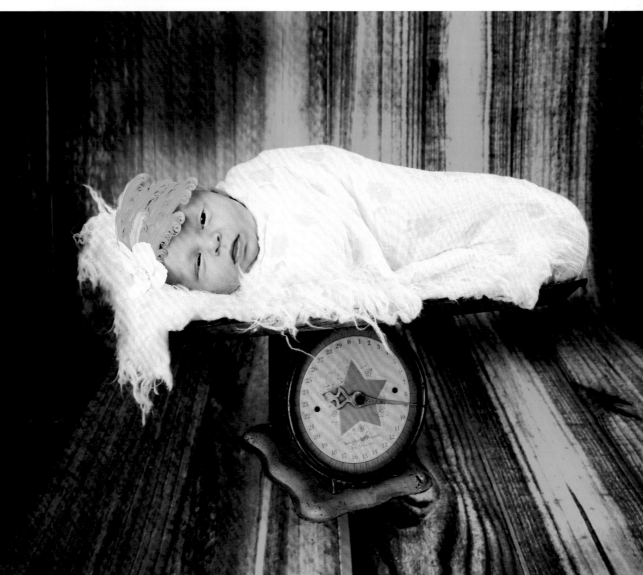

and changed. It takes time and lots of patience to hold steady through some crying to get the little one back to sleep. Many babies are born alert, giving us the opportunity to capture their eyes open; to get those sweet, sleepy baby shots, you need to take some extra time to rock, sing, and settle. Once baby is fully asleep, it should be easy to manipulate and pose them how you would like. A heavy sleeper looks adorable gently placed in props and everyday items that show their size and give us an idea of perspective. Props also enhance the character of the portrait.

This is the session from which parents will order baby announcement cards to send to friends and family, so close-ups of the baby's face will be needed; they work best for these cards. Baby announcement cards are a great way of getting more exposure for your work, so make sure your web site address is placed (discreetly) on them. Sending birth announcement cards is a common practice in the United States; it is much less common in other cultures. That's not to say that you shouldn't try offering them elsewhere, though—you just might be surprised how enthusiastic parents are to share news of their precious baby.

Preparing for a Newborn Session. For most new parents, a visit to your studio will be their first outing with the baby since its birth.

Offering birth announcement cards can help you spread the word about your business.

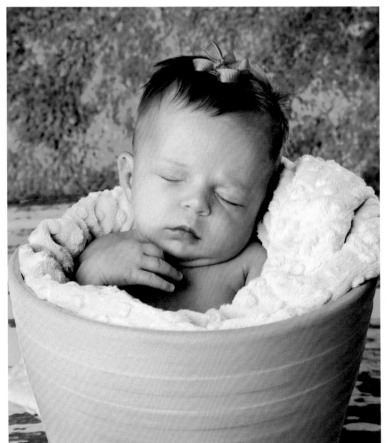

A heavy sleeper looks adorable gently placed in props.

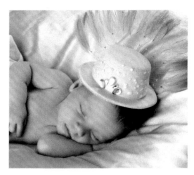

In my quest to create new looks, I've introduced this line of miniature top hats (www.mikamoo.com).

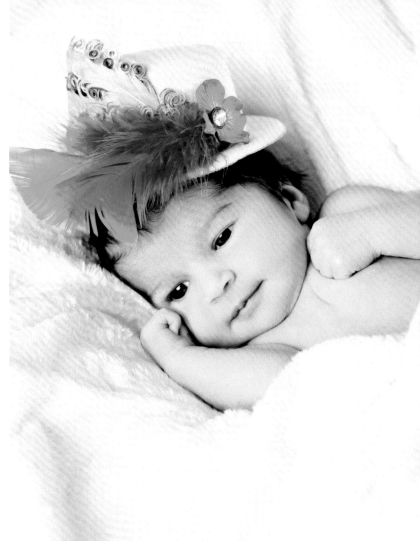

IDEAS FOR NEWBORN POSES

Babies have gorgeous little features. I just love taking photos of their hands, feet, ears, eyes, nose, mouth, etc., and compiling them into an artistic montage—I call this a "Kissable Collection." A newborn baby has much to offer in a portrait. Their little form reminds us how precious and vulnerable new life is. Those early days are gone in the blink of an eye, so capturing new lives while they're still itty-bitty is so important.

It's important to create a warm, relaxed environment so that Mom will be at ease. If Mom is stressed out the baby will sense it, so it's very important she feels calm when preparing for the shoot. Advise the mother to give herself plenty of preparation time—and to plan on an extra few items of clothing, since it's almost guaranteed that the baby will get sick on their "pretty" clothes just as they walk out the door!

The best time to capture a newborn's natural smiles and good mood are in the morning, soon after they have woken up. They should be well-rested and well-fed. Babies have a very small window of "good" time and a limited number of smiles, so don't use up all the smiles by playing with the baby before the session begins. If the baby decides halfway through the session that they need a

top up, don't stress; oblige their needs and feed them. You want both Mom and baby to be content.

Again, using props is a great way to showcase the baby's small size and add a sense of storytelling. Flower boxes, suitcases, hanging baskets, bean bags, glass bowls, wooden boxes, etc.—the possibilities are endless when you make a trip to the craft market and ask yourself, "Will a baby fit in this?" Babies love soft texture, so incorporate blankets, fabric, and rugs as something for the baby to lie on.

The Three-Month Session. The newborn is just a floppy lump that sleeps, eats, and poops all day—but at three months of age, the little one has become more alert and gained control of their head so that they can hold it up for a few moments. A three-month-old should be able to be placed on their tummy and push up on their elbows. At this age, babies can roll onto their sides and from their back to their belly. They can also manipulate their hands and grasp a toy. This is a great time to capture that gorgeous smile, so aim for some close-ups of the baby's face, too.

BELOW—At three months, close-ups of babies lying on their tummies work well. At this age, babies should be able to push up onto their arms.

FACING PAGE—Close-ups of babies' faces can show off their gorgeous eyes.

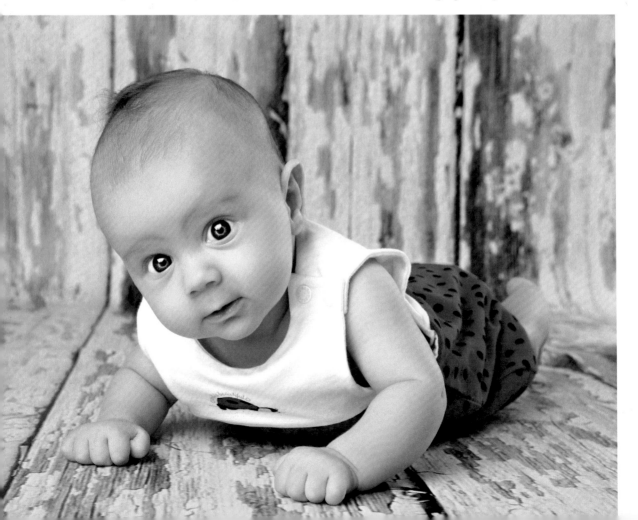

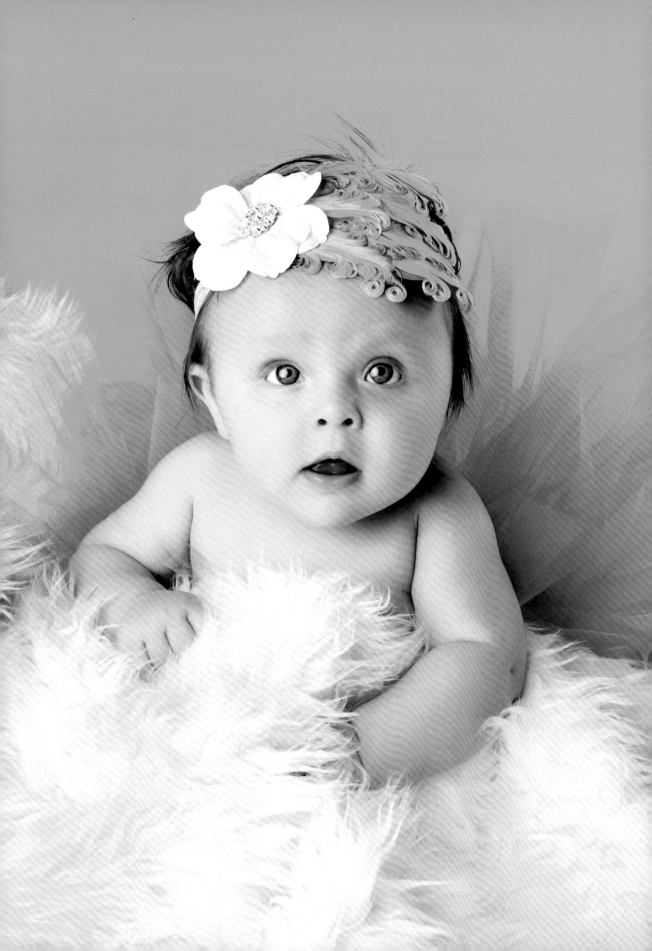

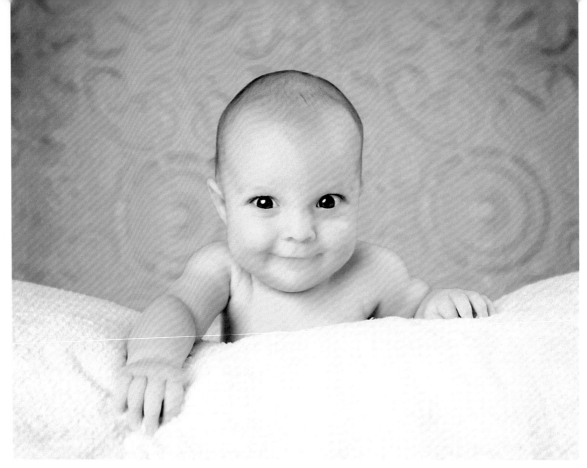

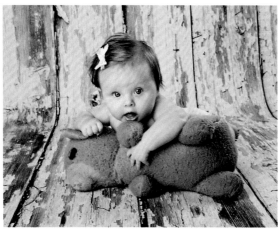

ABOVE—Use pillows to prop the baby up with their arms over the pillow for a more upright position.

LEFT—Incorporating props provides scale and helps showcase the baby's small size.

As babies gets older, however, the session times will get shorter. Their energy and attention spans will wane, so keep things moving along. Depending on baby's energy level, you could do two or three clothing changes—but my favorite images are naked shots of the baby lying on their tummy, looking up. Use pillows to prop the baby up with their arms hanging over the pillow for a more upright position. Including siblings and grandparents into this session works if they can hold the infant up so that the baby is facing the camera. If the sibling is too young to do this (under about four years old), it's better to wait for group portraits until the next session at six months, when the baby is sitting independently. (Refer to chapter 9 for more detailed information on handling older children with younger babies.)

The Six-Month Session. At six months, the baby has undergone some significant changes. They are eating solid foods so their tummies are

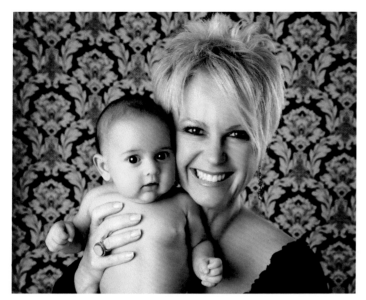
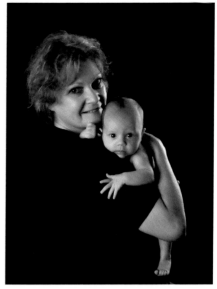

Including siblings and grandparents in the three-month session works when they hold the infant up so the baby is facing the camera.

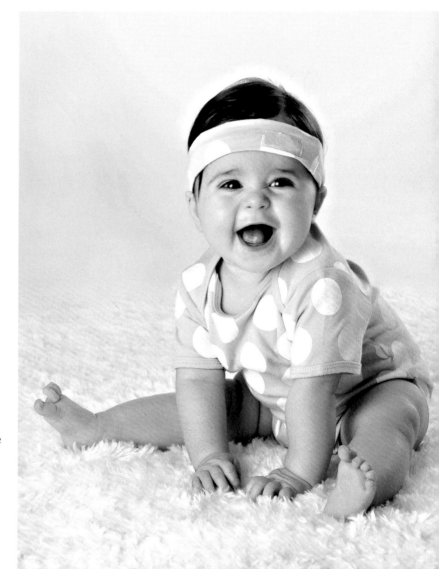

At six months, babies can sit in the tripod position with their hands forward for support.

fuller, they can sit in the tripod position (hands forward)—or even independently, without any propping required. At this stage, babies can hold toys and props and their expressions are very animated. Including siblings at this stage works better, since you won't have to worry about the baby being totally supported by the other child. An updated group portrait of all the family members is also worth doing at this point, since the baby is a little bigger and smiling from ear to ear.

FACING PAGE—Being an independent sitter means the baby can be photographed with props to tell a story.

BELOW—Look for very animated expressions from six-month-olds.

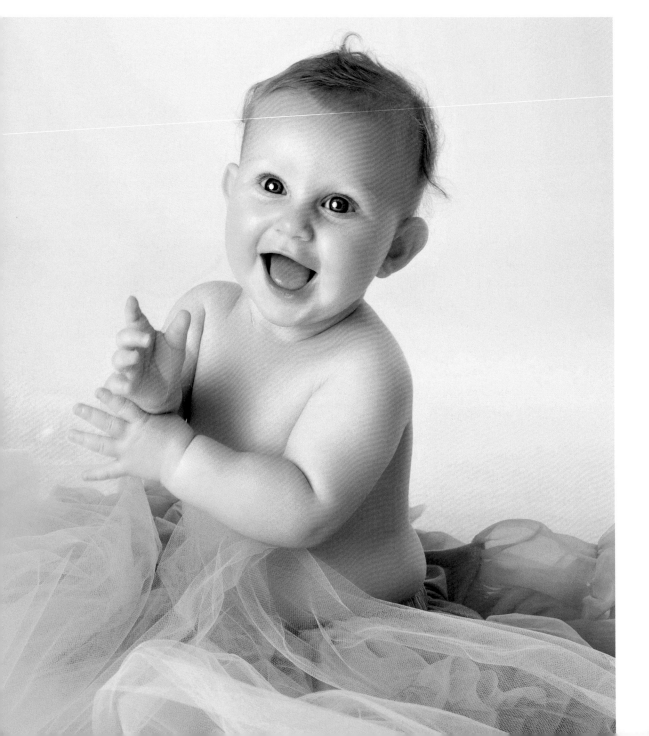

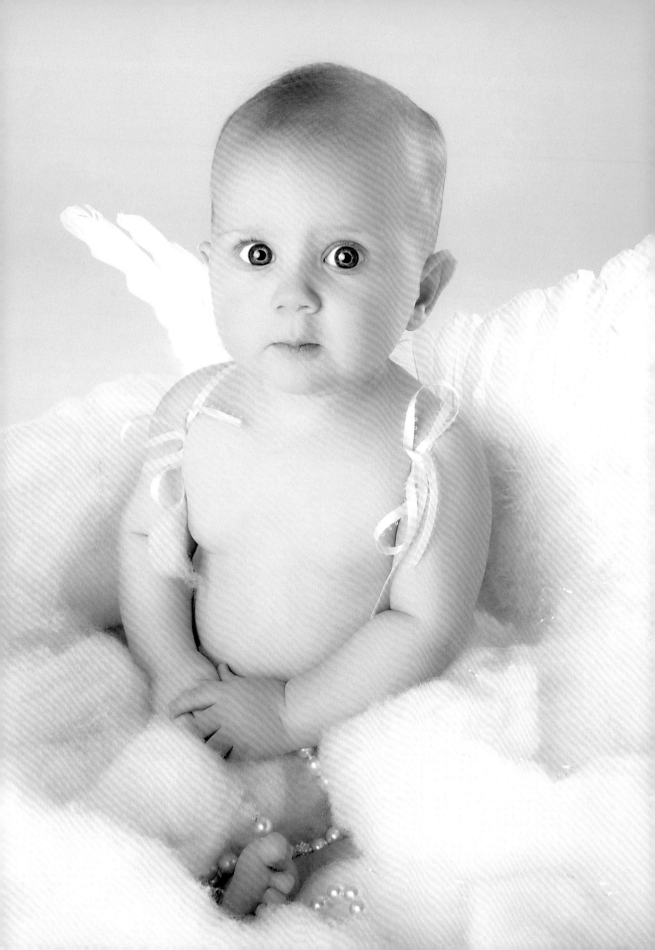

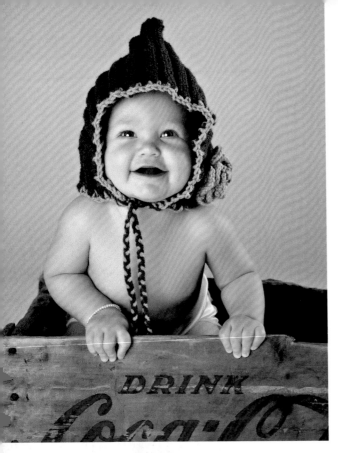

LEFT—Props help keep the baby amused and engaged during the session.

BELOW—Remember to capture those close-ups of the baby's big eyes. Parents just love them!

FACING PAGE—At nine months, most babies start crawling—so don't expect them to sit still!

The Nine-Month Session. At nine months, babies become more curious and have figured out cause and effect. Picking up and dropping things is a firm favorite, so using baskets, buckets, and small props will work well to keep the baby engaged. A nine-month-old can also experience some separation anxiety, however, so make sure Mom or Dad is sitting close by to offer reassurance. The baby will be proud to show off their standing and cruising skills, so provide a prop, basket, furniture, table, or a pair of legs that they

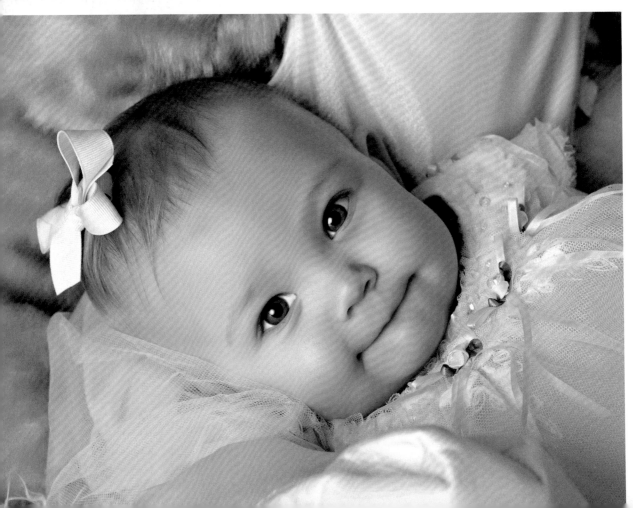

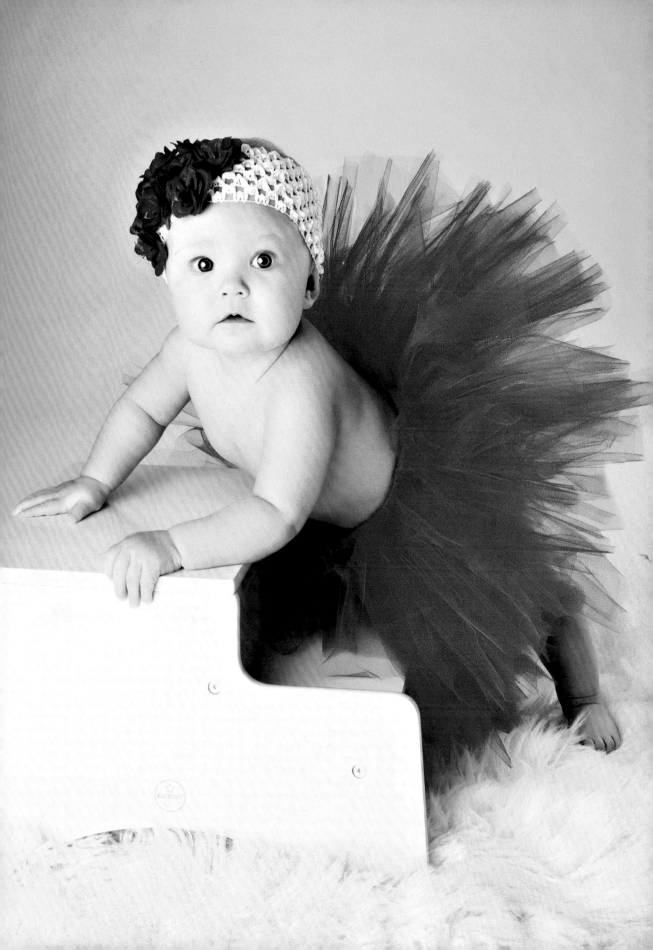

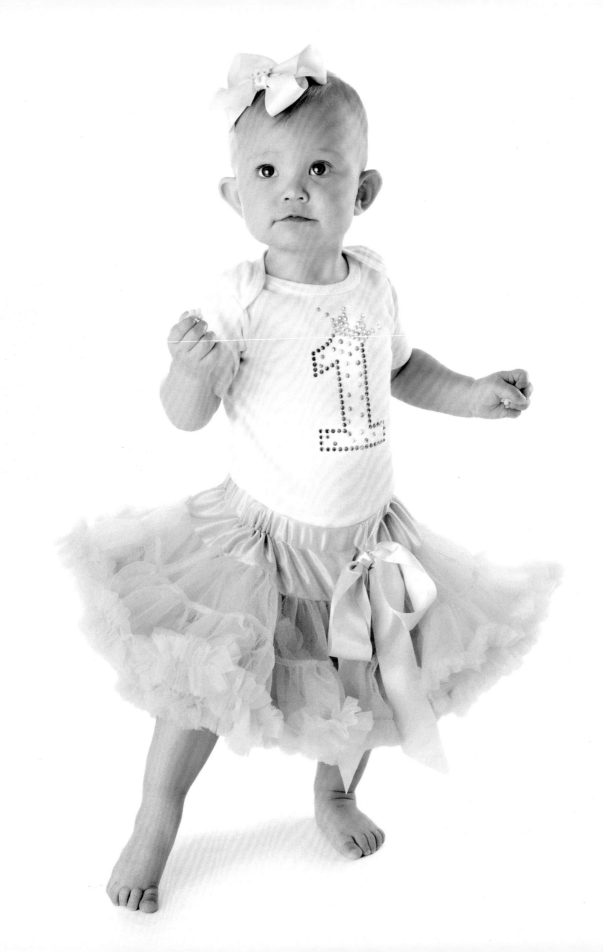

can hang onto in a standing position. Playing a game of peek-a-boo is bound to elicit some cute giggles and laughs.

The One-Year Session. Baby's first birthday brings lots of excitement and celebration. The baby is now officially a toddler. Lots of little ones learn to walk and run pretty quickly, so be prepared for a workout during this session. At this age, the child's attention span will also be extremely short, so it's important to keep the session progressing quickly and to change the prompt cues often so they stay engaged. Don't keep saying, "Smile! Smile! Look here!" all the time, hoping to capture a look of interest. Instead, try different things. I've found that offering stimuli in short bursts is the most effective way of getting their attention. My most effect trick is my squeaky chicken toy—which always gets a reaction from little ones.

The one-year-old session is when I love to schedule one of our signature "Pettiskirt Party" for girls or our "Trash the Cake" session for both girls and boys. Moms love to dress up their baby girls in pretty pettiskirts and tutus and they make fun, colorful portraits. I keep a selection of various colors and styles of dresses, skirts, and tutus with matching hats and onesies/babygrows on hand for these sessions.

For "Trash the Cake" shoots, I advise parents to bring the outfits they want their child to wear so that we can photograph those first. Then we

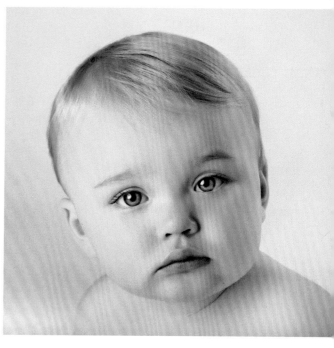

FACING PAGE—Lots of kids learn to walk and run pretty quickly, so be prepared for a workout!

TOP RIGHT—Holding a one-year-old's attention can be tricky; they have very short attention spans.

BOTTOM RIGHT—Even serious portraits capture wonderful memories.

proceed to the messy part of destroying a birthday cake. Not every child likes to get dirty (I've found more boys than girls get completely into the experience), but for those who do, the resulting images are hilarious! The fun part is watching their expressions of surprise and excitement as they discover the texture and taste of yummy cake. Keep your camera ready; as soon as you put the cake in front of the baby, things will get messy quickly. Creating a documentary collection of the images in the order they were taken makes for a great album, slide show, and card collection. We offer a press-printed birthday celebration card that parents can use as a birthday party invitation or announcement—and moms love this product. Again, remember to include your web site address so you'll be generating referrals.

Album Collections. At the end of the baby's first year, you will have a lovely collection of im-

A postcard promoting our "Trash the Cake" sessions.

ages that tell the story of the child's growth and development. After each session, the images will have been narrowed down to the parents' favorites, so the fully retouched images should be ready to go. This is the perfect time to create a custom-designed storybook album—and it's another way of offering a complete turnkey service

Moms love to dress up their baby girls in pettiskirts and pretty hair bows for these sweet, colorful portraits.

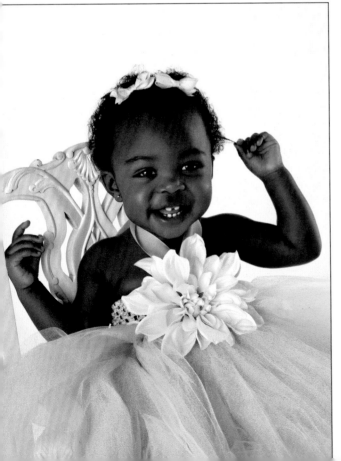

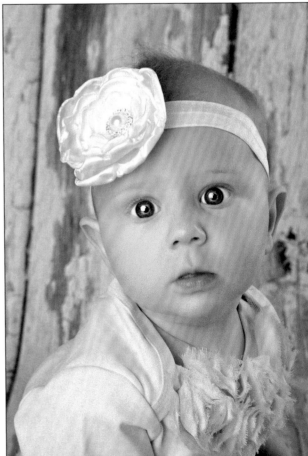

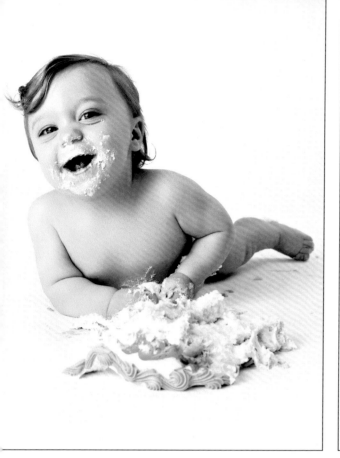

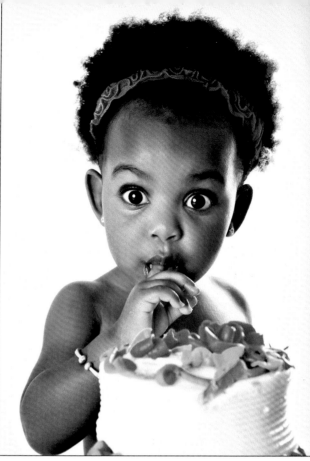

LEFT—For those who get really into it, "Trash the Cake" images are hilarious!

RIGHT—Watch the child's expressions of surprise and excitement as they discover the texture and taste of yummy cake.

to parents. Incorporating design elements and color schemes to match their tastes and style will make it even more special. There are several ways you can create albums and many different album manufacturers available, so do some research and decide on the style and price you're willing to offer. We have two variations by two companies. Our upscale leather bound albums are by Finao Albums, and our press-printed books are printed and bound by our photo lab, White House Custom Color.

A custom-designed album documenting the child's first year is a keepsake parents will treasure.

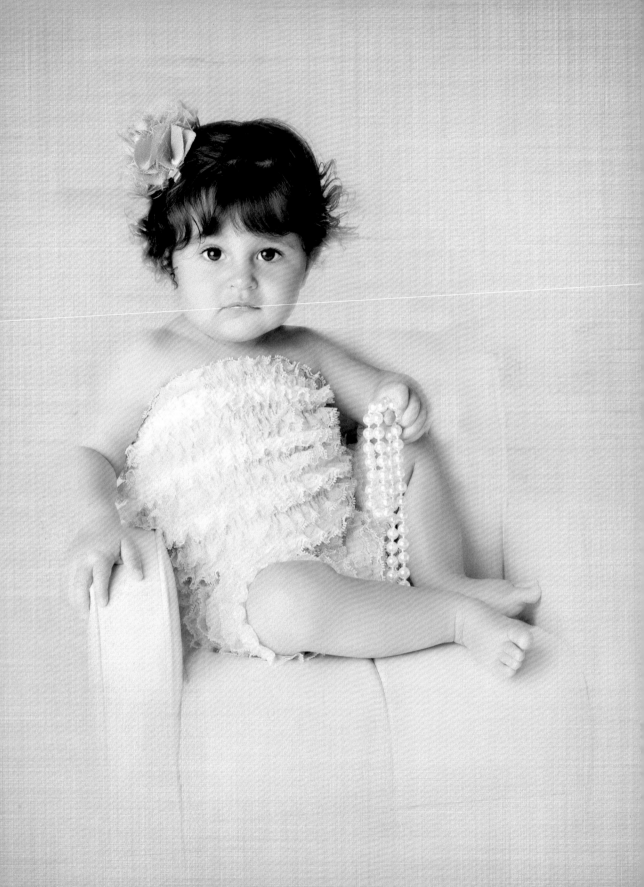

9. PORTRAITS OF TODDLERS AND KIDS

"Children are the hands by which we take hold of heaven."—*Henry Ward Beecher*

Including older siblings offers you the opportunity to achieve higher sales.

Very often, the families you photograph will have more than one child. A newborn baby photographed on its own is a wonderful keepsake for the parents, but including older siblings offers you the opportunity to achieve higher sales. The majority of families who come to my studio for newborn portraits have kids no older than eight years old; this is just the typical dynamic of young families. Most often, the older siblings are very active toddlers under the age of three who require a special kind of focus—and patience!

FACING PAGE—Simple clothes in subtle colors keep the emphasis on the child's face.

RIGHT—A classic portrait of kids of varying ages works well when the clothing is simple and the faces are posed close together.

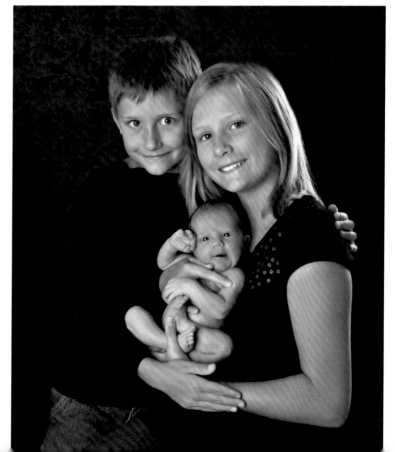

WARDROBE PLANNING

Simplicity is the key to planning an appropriate outfit. Solid colors are best. Bright or light pastel clothing looks good in portraits taken against a white or light background. Blue, white, ivory, khaki, or salmon look lovely outdoors against green foliage. Burgundy, brown, tan, or gray are well-suited to late autumn. Kids photographed outdoors in the autumn look fabulous dressed in a single color—for example, green against the bright orange fallen leaves, or red against the green foliage.

Avoid large or bold patterns, wording, checks, stripes, dots, and spots; these only draw attention away from the face, the most important part of the portraits. Older kids often want to show off their branded or character clothing, but brand names will date the photo in years to come and can be quite distracting. Try to steer clothing decisions away from those branded items by suggesting (subtly of course) a simpler alternative (keep that Spiderman shirt for playtime not for photos).

If you are having a group or family portrait taken, dress everyone in the same style of clothing but not necessarily the same color. It's best not to mix casual and formal attire in the same shot, as formal clothing results in more formal poses. If you would like a more relaxed portrait, or if you select an outdoor location, choose

Mom and Dad always want their children to look their best.

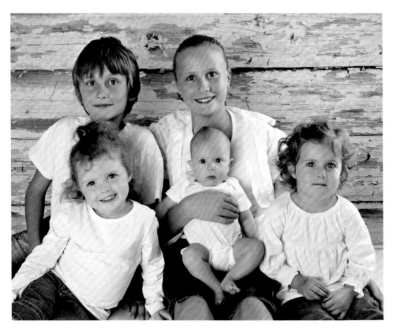

Denim and a solid shirt work well to create a finished look.

TIPS FOR SUCCESSFUL SESSIONS

1. Children are usually at their best mid-morning, so schedule the session for a time when they are happy and well-rested.
2. It's a great idea for kids to bring along a few of their favorite small toys. Having some familiar things nearby will help them feel more secure.
3. It is best not to offer food or drink to children during the portrait session, as it will distract their attention and cause unflattering facial expressions.
4. Don't worry about potential tears or tantrums; as long as you stay calm and don't rush things, you will be prepared for any eventuality.
5. The surprise of flashing lights can be a little scary, so give them time to get comfortable. Consider having Mom or Dad sit with them in the photo so that they can see it's no big deal. After ten minutes, they will usually be happy to be the center of attention!

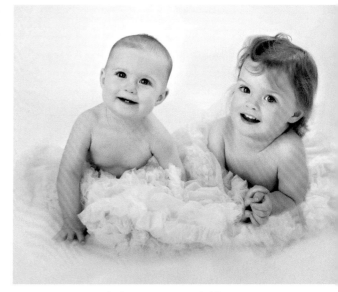

Tummy poses can help get younger children to cooperate and sit closer together.

casual, comfortable clothing (denim works well). Also, consider that children look best photographed with bare feet; shoes tend to make their little feet look much bigger.

Any haircuts are best done several days before the portrait; the hair has a more natural appearance after is has grown out for a few days. It's always a good idea to bring along a brush or comb to tidy up and tame any flyaway hairs.

KNOW WHEN TO RESCHEDULE

If the child shows any signs of illness (runny nose, raised temperature, coughing, general crankiness), I always advise parents to reschedule their appointment when the child has recovered. Both

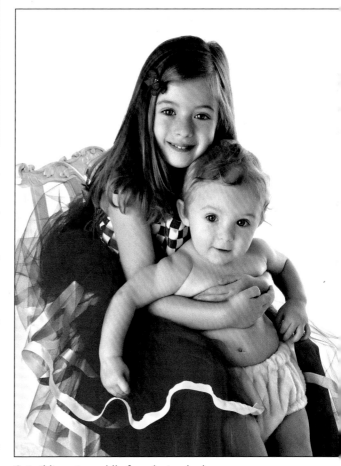

Get siblings to cuddle for a loving look.

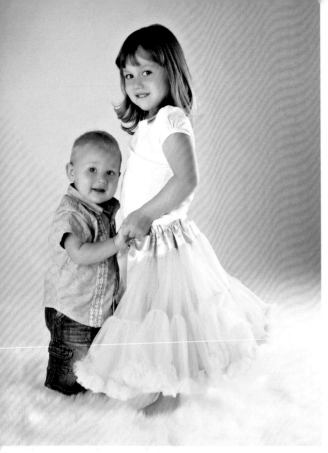

Play games and dance around to get natural-looking expressions.

sion, keeping things moving along by directing your clients in a calm and friendly but authoritative tone will help you stay in control. To avoid any wild behavior or equipment breakage, it's important to tell the children how things are going to work as soon as they enter your shooting space ("Welcome to Joe's studio—we are going to have fun today! Kids, we need to remember not to grab any of the equipment you see here, because we don't want anyone getting hurt if it falls down. We all need to be good listeners so that we can get a treat from the treasure box when we are done."). Mom and Dad will greatly appreciate you taking control, and they will be put at ease knowing you are the professional and fully in control. Most of all, have fun and enjoy what you're doing—your enthusiasm will show!

Sometimes, it's not just the kids who need to be controlled. Mom and Dad can be very helpful as quiet supporters of their little gems—but I've also had experiences where I'm calmly talking to the child and the parents are standing behind me yelling, "Look here! Smile for the camera! Say cheese!" Besides being annoying, this can elevate the tension; the voices get louder and louder as everyone fights for the child's attention. In these instances, I calmly and courteously ask the parent to be a quiet supporter, to take a seat and move behind me so that I can do my job. It works really well when parents stand behind the photographer so young children look in the direction of the camera. Another great tip is to distract the parents by giving them a job to do or something to look at so that it doesn't seem that they have been chastised. I've found that most parents are happy to oblige—and they are thrilled with the results of their precious darlings looking content, happy, and simply adorable!

the parents and the child will enjoy the experience far more if everyone is content and happy. (*Note:* Little ones usually feel under the weather for a few days after they have had their inoculations, so it's best to schedule any session at least two weeks after their shots.) Putting them through the trauma of feeling unwell *and* having to cope with an unfamiliar environment like a studio will only result in a crying child and a frustrated parent. We want the child to have happy memories of their photo experience. We also don't want to infect others, so we ask that they please don't share those germs!

STAY IN CONTROL

Sleep-deprived parents will have very little patience for taming a wired toddler. During the ses-

On a related note, grandparents can be either a help or a hindrance, as well. In general, it's best to keep the people in the shooting area to a minimum.

GIVE THEM SOME CHOICE

It's best not to force children into a pose; the results will be stiff and stilted. Children instinctively know what feels natural and the best results come from those poses. I personally feel that a child needs to feel like my studio is an extension of their play area, so they go home with the memories of an enjoyable experience.

A child may be more cooperative if you give them some choice. Offering them an option to choose between toys, dress-up clothes, or props will help gain their trust and make them more amenable. Never ask a young child or toddler if they would "like" to do

Include Mom and Dad by sandwiching the child in between them so there is no escaping!

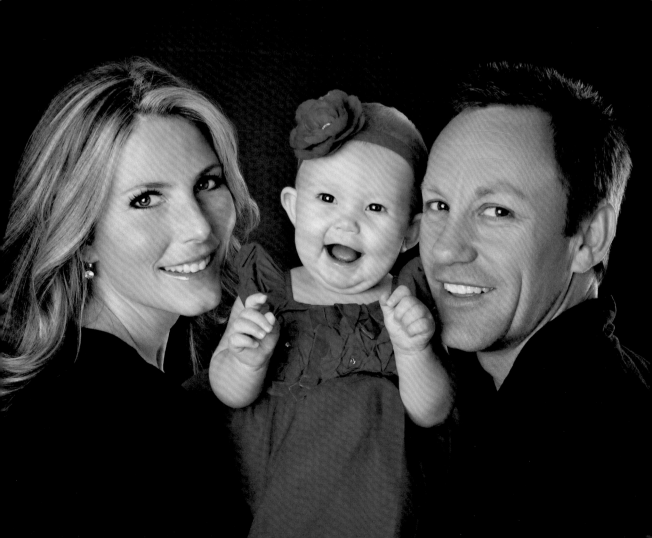

something ("Would you like to sit here on the floor so I can take your picture?"). Instead of an open question like that, provide either a loaded instruction ("It would be so much fun to sit on the floor criss-cross-applesauce!") or a "this or that" option ("Which dress would you like to wear, the red one or the pink one?").

IT'S 80 PERCENT PSYCHOLOGY

Photographing kids is 80 percent psychology and 20 percent camera technique. It's the emotion and personality of the child that makes images endearing to a parent. Even images that are not technically flawless will often sell just because the parent loves the expression. This is not to say that bad technique and offering poor-quality images is acceptable—absolutely not! As professionals we must provide the client with exceptional quality. But it is important to recognize that a big part of your success will rely on your ability to elicit and capture great expressions.

During my photo sessions I choose words that kids associate with fun, laughter, and being relaxed. My favorites are: "I love candy!"; "Daddy wears diapers!"; "I love the beach!" and "Stinky

If all else fails to get them to sit still, have the kids lie down and photograph them from above.

A big part of your success will rely on your ability to elicit and capture great expressions.

Sing, dance, jump, play—do whatever it takes to get those expressions!

feet!" Sing their favorite songs along with them, talk about their favorite television show, or ask what their favorite candy is. Whatever you do, don't ask kids to say "Cheese!" Many parents try to coax a smile out of their little ones by using this phrase whenever they bring out their camera. As a result, kids often associate these words with a forced smile.

It is advisable not to tell the child they are having their picture taken or to threaten them that they "better behave." Instead, give them a positive mental image first and tell them that they are going to have fun. Distract them by changing the topic frequently, and make them say words that end with "e" for a natural smile. If you think of ways to use mental distractions and associations, you'll be pleased with the results.

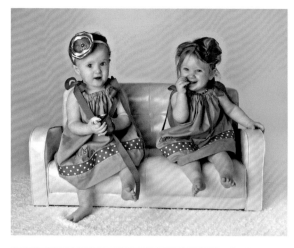

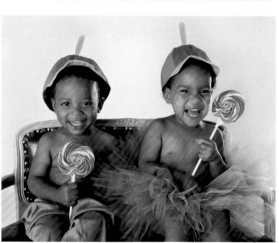

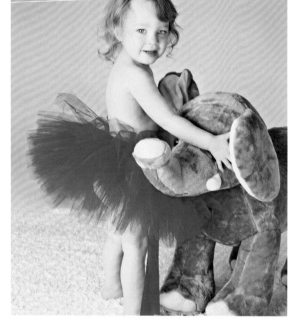

Kids have short attention spans, so work quickly.

TWENTY MINUTES OR LESS

A child's attention span is short and they will lose interest quickly once the novelty of a new place wears off. It usually takes them ten minutes to warm up, then you have ten minutes of optimal shooting time—followed by ten minutes of them getting overstimulated and sometimes out of control. Keep the activities moving along at a quick pace so that kids don't have time to even think about behaving badly. Watch for signs that the child has had enough, though, and start to wind things down when you sense the end is near. To calm the child (and sometimes the parents), use a lower tone of voice and speak more slowly. Use wrap-up words like, "Now we're going to put Teddy to bed. Night-night, Teddy."

Most importantly, offer lots of praise during the session for positive reinforcement.

BRIBERY WORKS!

Using bribery to achieve a child's cooperation is not a bad thing—as long as you do what you promise. Kids take you literally, so if you say they can pick from the candy box, don't forget to let them. Offering a reward to get them to oblige to your requests works well if you base it on them earning it.

When kids enter my studio I make a point of explaining how things are going to go so they know what to expect and that there is a reward waiting for them at the end of the rainbow. Before they can think about getting up to mischief, I tell them that, as long as they are good listeners, they get to pick their favorite candy from our treasure box. The treasure box is the largest box of candy, treats, and stickers they have ever seen and it has an intriguing lid so that it leaves some-

thing to the imagination. I tell them that they will get to see what's inside after we have taken their photos.

Sometimes, I've come across unruly children whose parents don't discipline them. They are the ones who need the most directed instruction right from the start. If the child proceeds to take a candy out the box before they have been given permission, it's important to say that they can't have a treat until we are done. If you let them get away with it before the session you will have an almost zero chance of maintaining control. On some occasions, it's even the parents who need to be reprimanded for allowing it. So I've learned that it's important to gently but firmly state that you mean business.

Keeping it upbeat, lavishing on lots of praise, and mentioning the treat box throughout the session keeps them thinking of the treat they are eagerly anticipating.

A promotion we did to announce a special portrait event.

10. BUILDING YOUR LOVE BRAND

"The best and most beautiful things in the world cannot
be seen, nor touched, but are felt in the heart."—*Helen Keller*

As I've stated throughout this book, keeping a client costs you far less than trying to attract a new client—so it makes sense to keep your existing clients happy and give them a reason to keep doing business with you. Simply referring to each person by their name goes a long way in showing you are paying attention, but there are lots of other little ways to stay in your clients' hearts (and on their minds). Making the extra effort to offer these little perks is especially important in a boutique business, when our clients are each making a substantial investment.

Clients expect custom artwork—and their experience at your studio should be just as customized.

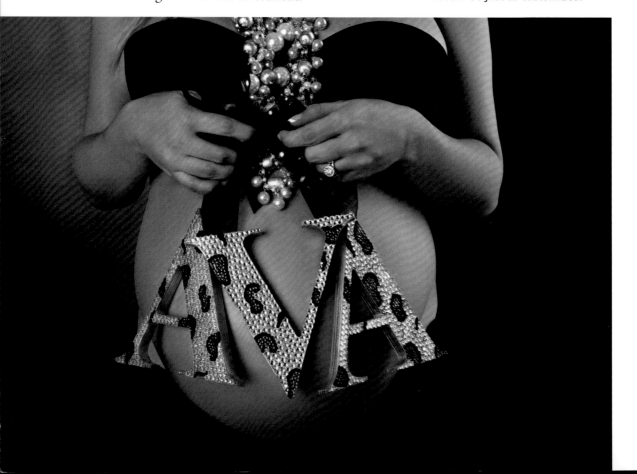

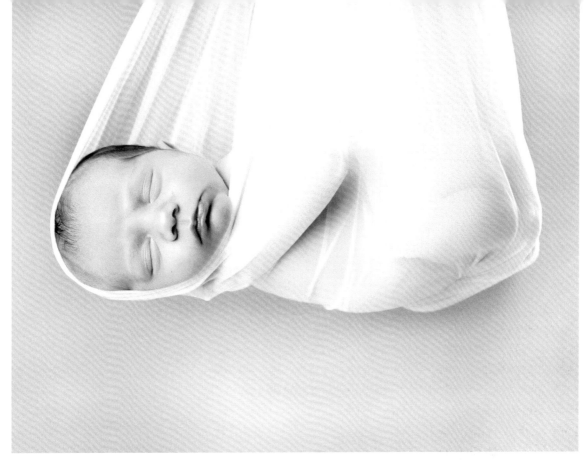

Use a simple image as a base for designing your own custom card.

CUSTOM CARDS

Thank-You Cards. After the session, sending a hand-written note is a nice way of thanking the client for placing their trust in you—and it's much more personal than an e-mail. There are several suppliers on the market who offer custom printed stationery. Additionally, many photo labs are now offering digital press-printed cards at a reasonable price. My favorite are the cards by White House Custom Color; their paper range and clear image quality make them a standout. Simply Color Lab also offers a great selection of different paper weights and finishes for their press-printed products.

Birthday Cards. The second most important thing to remember about a person (after their name) is their birthday. No matter how old we get, we all like to be appreciated on our birthday. As Dr. Seuss says "A person's a person, no matter how small." Keeping an accurate database of your clients will help you pick out a list of upcoming birthdays so that you can send them on time. You can also include a voucher/coupon/gift certificate to give them an incentive to do business with you again—and including a current promotional idea or offer will give them a reason to call. There are various methods for sending out birthday cards, from buying pre-printed ones in bulk to having custom ones printed through your lab. (As noted previously, Send Out Cards offers a fantastic way of automatically sending an individualized card. For a free trial, visit: www.sendoutcards.com/mimikacooney).

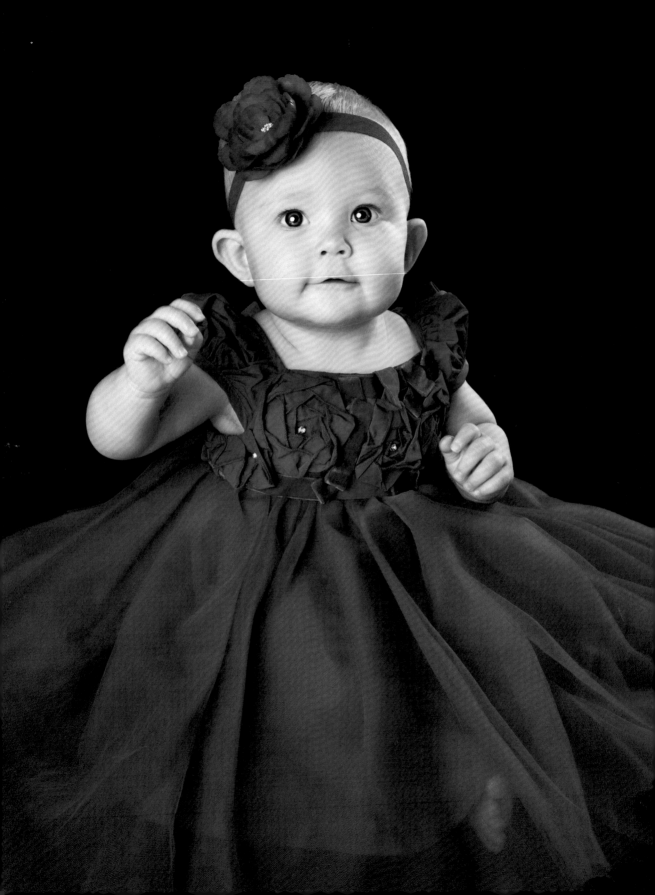

FACING PAGE AND ABOVE—Use the seasons to add a storytelling element. Customized cards with these images are bound to create a stir.

Play-Date Cards. Surprising Mom with an extra gift goes a long way in spreading the love. Busy moms with babies and young children have very little time to do things for themselves, so consider providing them with their own play-date cards, featuring Mom's contact info and an adorable photo of her child(ren) from their last session. Printed like business cards, these can be produced very economically. When your client meets another mom out shopping and talks about getting together to let their kids play, she can then hand her friend a play-date card with all her info. If all goes well, the friend will comment on how lovely the photo is, and your client will tell her friend all about you. Make sure your contact information is also included discreetly on the card so the newly referred friend can easily get in touch with you. You may even want to include a special offer or coupon ($25 off or free wallets) for both the referring mom and the new friend as an incentive to get them talking.

LIFETIME PORTRAIT PROGRAM

One of the first questions people ask when inquiring about professional photography services is, "How much is your session fee?" The session fee covers the time and talent of the photographer and definitely needs to be valued. However, there are times when forgoing the session fee works in your favor.

This is an idea I borrowed from Jeff and Kathleen Hawkins. Simply pick a list of your top-paying clients—people who love what you do and who are loyal to your brand—and offer them a space in your Lifetime Portrait Program. This is a membership-type club offered for "VIP" clients who receive exclusive offers, special discounts, and free sessions for life. Yes—that's right: they never pay a session fee again! This removes a significant barrier to booking future sessions and placing (hopefully frequent!) orders. By offering

AFTON

Thank you for believing in us!
Enjoy a gift with our compliments....
Book your session & claim your
$100 gift card
photo*lyrical*™
photography 1.888.344.0894
 WWW.PHOTOLYRICAL.COM

Our brag cards are a gift we design featuring Mom's favorite image.

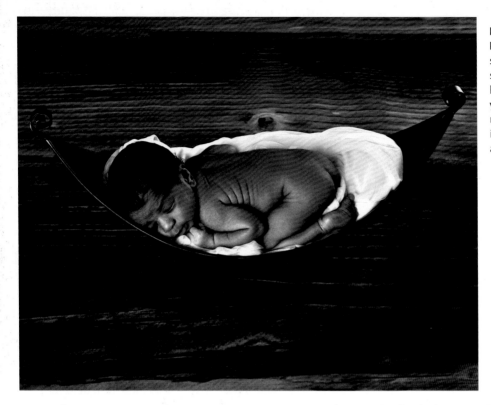

no-fee, easy access to your services, you are creating goodwill and building a sense of loyalty.

ESTABLISHING THE VALUE OF PHOTOGRAPHY

Competition nowadays is fierce and there are new photographers entering the market all the time who are willing to give their services away for next to nothing, charging pitiful prices just to get the deal. This negatively affects the entire photographic industry by lowering the perceived value of photography in the minds of consumers. In my opinion, photographers who charge only a small fee for their time and happily hand over a CD of digital negatives are digging their own graves. It's a lazy approach and gives the sense of a "grab and run" business, which does not instill any confidence that this business is built to last.

If we all want to stay self-employed doing what we love, then we need to work together to keep the standard of photography high. Consumers have become wise; with the accessibility of the Internet it has become easy to get rock-bottom prices on all kinds of goods and services. When it comes to photography, however, this is not necessarily a good thing. People who bargain shop often find themselves complaining bitterly when things don't turn out like they expected—and these bad experiences hurt all our reputations as professionals. Instead of cutting corners to grab a few bucks, we all need to provide a quality service with quality products. That's how we keep customers coming back and build respect for our profession.

The truth of the matter is, most start-up businesses won't make it past the first five years. If you want to be one of the survivors, you need to invest some effort in creating lasting relationships with your clients.

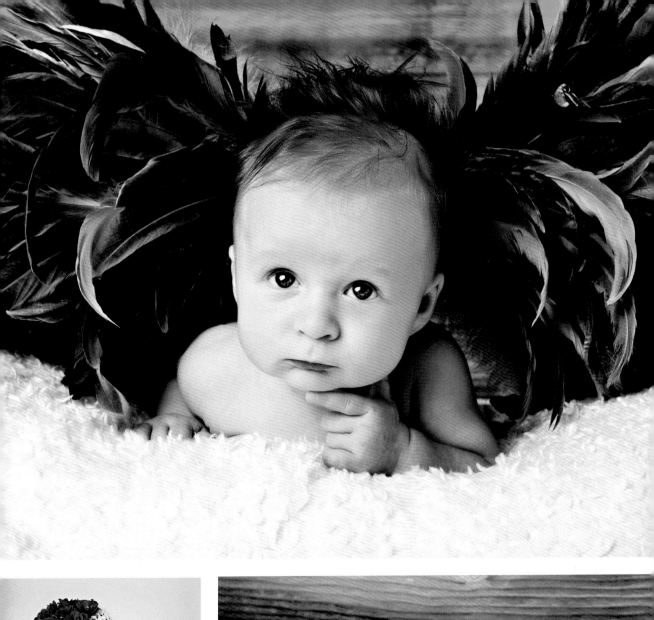

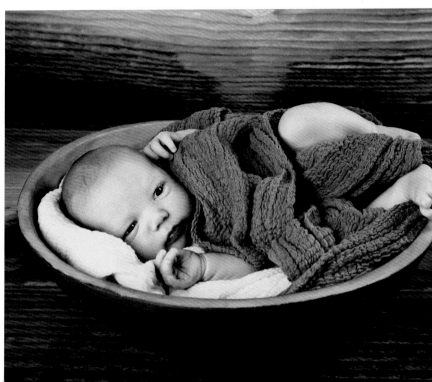

11. WORKING WITH CHARITIES

"There can be no keener revelation of a society's soul
than the way in which it treats its children."—*Nelson Mandela*

As artists, I believe we have a duty to use our talents for the good of others. The pursuit of profit keeps us busy most of the year, but we can spare a little time in the pursuit of philanthropy. Helping charities generates goodwill for your business and more love for your brand, as you are perceived as generous and authentic. Additionally, I find it personally fulfilling to help others who are less fortunate.

For the last three years, we have dedicated one month each year to raising funds for a charitable cause. So far, our annual calendar projects have raised close to $10,000 for charities. Each year we've used a different theme—and that alone has taught me many valuable lessons along the

way. The following are examples of the charities I support and of the charity calendars we created for them. For photographers who are interested in setting up their own charity project, I offer a charity planning pack for purchase on my web site (www.mimikacooney.com).

NILMDTS (WWW.NILMDTS.ORG)

Now I Lay Me Down to Sleep (NILMDTS) is an infant bereavement photography charity founded by renown photographer Sandy Puc'. Through their work, grieving parents are provided with lasting memories of their dying or deceased baby in an artful and sensitive manner. NILMDTS gently provides a helping hand and a healing heart. This free service is provided by volunteer photographers who give their time to capture the images and supply a free CD compilation of fully retouched and printable images. Area coordinators deal with requests from local hospitals

LEFT—Themed as cotton-candy, these twins loved modeling for our calendar.

FACING PAGE—My studio produced a calendar project as a benefit for NILMDTS. It included real moms with their newborn babies photographed in stylized fabric wraps.

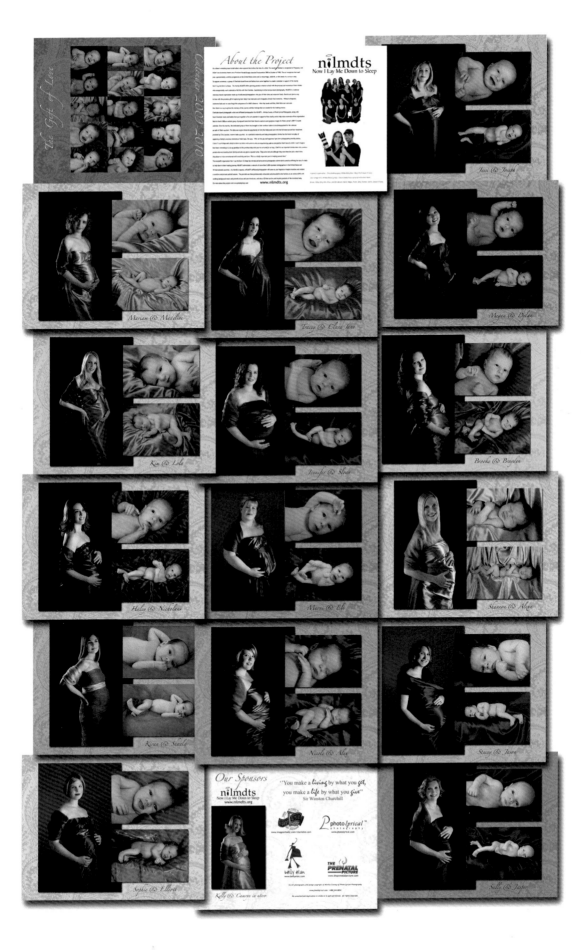

and call photographers on their list to service requests. The service is required within hours, as babies deteriorate quickly once they pass, so the majority of cases are on a last-minute basis. This service covers still births, early deliveries, and babies taken off life support. It takes a strong person with a big heart to volunteer. Although it may seem hard to imagine doing this, you'll be surprised at how big your heart can stretch.

serve as catalysts to help orphans and vulnerable children. Their slogan is, "Adopting dreams. Raising tomorrow's leaders." Projects are underway in my home country of South Africa, as well as in Rwanda and Southern Sudan—and their projects are expanding globally. The charity supports such programs as feeding children, developing sustainable gardens, building schools, and constructing healthcare facilities.

MAC (WWW.MOTHERINGACROSS CONTINENTS.ORG)

Mothering Across Continents (MAC) is a 501c3 non-profit organization through which women

BELOW—Our 2009/2010 benefit calendar for Mothering Across Continents was called "Tasty Treats & Movie Stars."

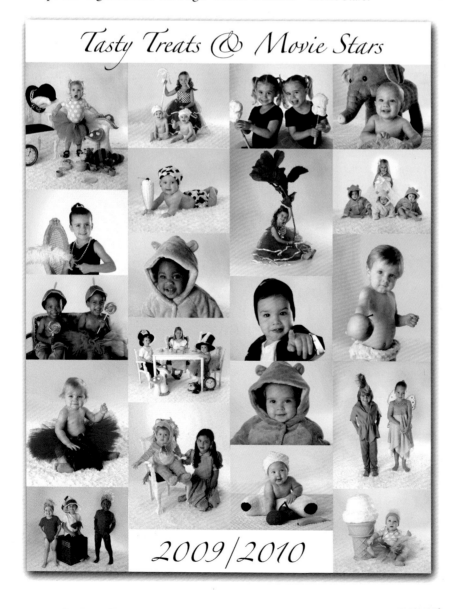

Tasty Treats & Movie Stars

2009/2010

RESOURCES

RECOMMENDED READING

Covey, Stephen R. *The 7 Habits of Highly Effective People*. Free Press, 2004.

Gitomer, Jeffrey. *Little Red Book of Selling: 12.5 Principles of Sales Greatness*. Bard Press, 2005.

Gladwell, Malcolm. *Outliers: The Story of Success*. Little, Brown & Company, 2008.

Gladwell, Malcolm. *The Tipping Point: How Little Things Can Make a Big Difference*. Back Bay Books, 2002.

Gladwell, Malcolm. *What the Dog Saw: And Other Adventures*. Back Bay Books, 2002.

Godin, Seth. *Permission Marketing: Turning Strangers Into Friends and Friends Into Customers*. Simon & Schuster, 1999.

Grey, Christopher. *Master Lighting Guide for Portrait Photographers*. Amherst Media, 2004.

Hawkins, Kathleen. *The Kathleen Hawkins Guide to Sales and Marketing for Professional Photographers*. Amherst Media, 2008.

Heath, Dan and Chip. *Made to Stick: Why Some Ideas Thrive and Others Die*. Random House, 2007.

Joel, Mitch. *Six Pixels of Separation: Everyone Is Connected. Connect Your Business to Everyone*. Business Plus, 2010.

Lindstrom, Martin. *Brand Sense: Build Powerful Brands Through Touch, Taste, Smell, Sight, and Sound*. Free Press, 2005.

Pink, Daniel H. *Drive: The Surprising Truth About What Motivates Us*. Riverhead Trade, 2011.

Vaynerchuk, Gary. *Crush It: Why Now Is the Time to Cash In on Your Passion*. Harper Studio, 2009.

Vaynerchuk, Gary. *The Thank You Economy*. HarperBusiness, 2011.

MY LINKS

Studio:	www.photolyrical.com
Blog:	www.mimikacooney.com
Facebook Business Page:	www.facebook.com/photolyrical
Facebook Personal Page:	www.facebook.com/mimikacooney
Photography Fashion:	www.mikamoo.com
	www.facebook.com/mikamoodesigns

VENDORS

Royalty-Free Music:	Triple Scoop Music (www.triplescoopmusic.com; use code MIMIKA)
Slide Shows:	Animoto (www.animoto.com; use code hqjrmfws)
	eMotion Media (www.emotionmedia.com; use code MIMIKA)
Newsletter Hosting:	Constant Contact (www.constantcontact.com; use code PhotoLyrical)

Lab and Album Services:	Finao Albums (www.finaoonline.com)
	Pictage (www.pictage.com)
	Simply Canvas (www.simplycanvas.com)
	Simply Color Lab (www.simplycolorlab.com)
	White House Custom Color (www.whcc.com)
Frames:	GNP Frame (www.gnpframes.com)
	Wild Sorbet Frames (www.wildsorbetframes.com)
Business Cards:	Miller's Professional Imaging (www.millerslab.com)
	Vistaprint (www.vistaprint.com)
	White House Custom Color (www.whcc.com)
Blog Hosts:	Blogger (www.blogger.com)
	BlogSpot (www.blogspot.com)
	Tumblr (www.tumblr.com)
	WordPress (www.wordpress.com)
Blog Themes:	NetRivet (www.netrivet.com)
Note Cards:	Send Out Cards (www.sendoutcards.com/mimikacooney)
	Simply Canvas (www.simplycanvas.com)
Photo Bags:	Gina Alexander Bags (www.GinaAlexander.com)
Software:	Adobe Lightroom (www.adobe.com)
	Adobe Photoshop (www.adobe.com)
	BrownBookIt (www.brownbookit.com)
	Design Aglow (www.designaglow.com)
	Florabella (www.florabellacollection.com)
	NetworkedBlogs (www.facebook.com/networkedblogs)
	Paint the Moon (www.paintthemoon.com)
	ProSelect (www.timeexposure.com)
	Successware (www.successware.net)
	Tweet Adder (www.tweetadder.com)